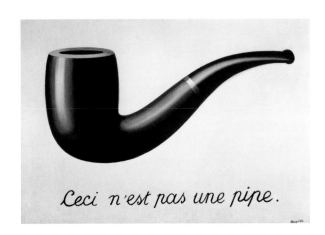

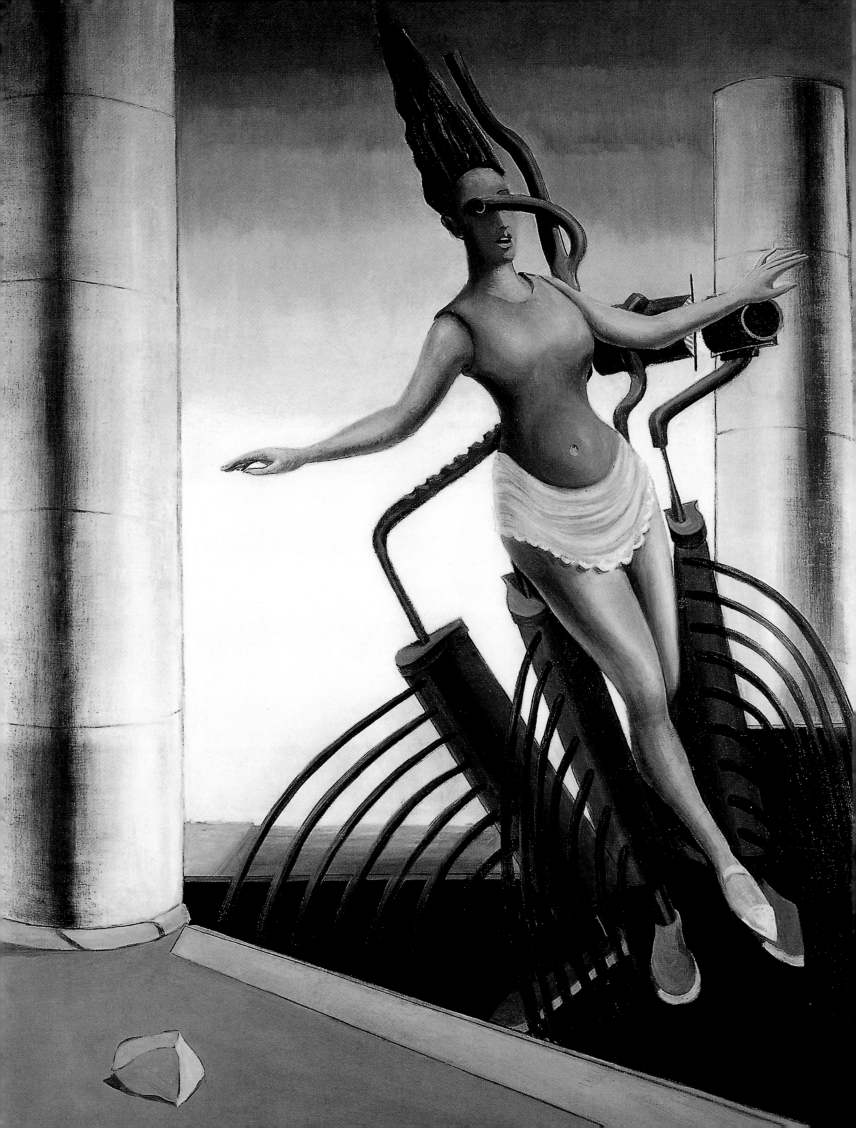

Surrealism

CATHRIN KLINGSÖHR-LEROY
UTA GROSENICK (ED.)

TASCHEN

HONG KONG KÖLN LONDON LOS ANGELES MADRID PARIS TOKYO

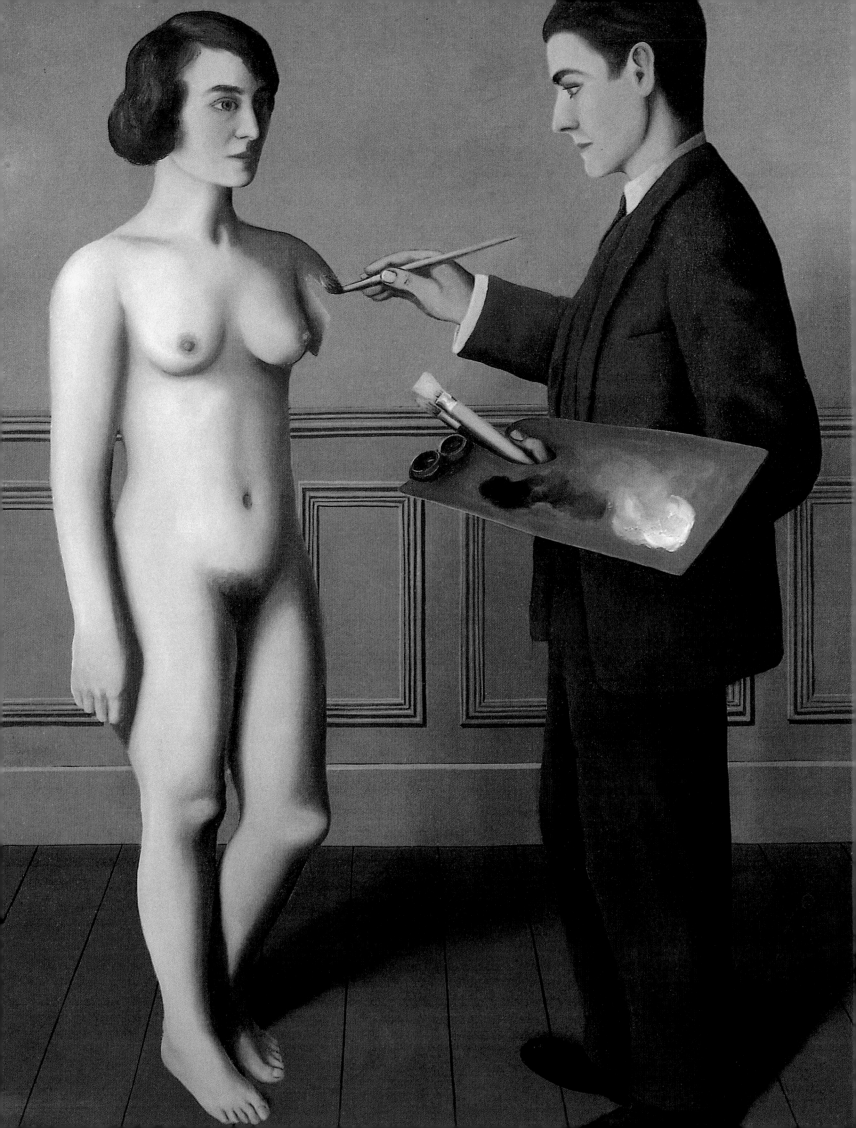

Contents

6 **A new Declaration of the Rights of Man**

26 **HANS ARP** — Concrete Sculpture
28 **HANS BELLMER** — The Doll
30 **BRASSAÏ** — The Image as Produced by Automatic Writing
32 **GIORGIO DE CHIRICO** — Mystery and Melancholy of a Street
34 **GIORGIO DE CHIRICO** — The Disquieting Muses
36 **SALVADOR DALÍ** — The Enigma of Desire - My Mother, my Mother, my Mother
38 **SALVADOR DALÍ** — The Persistence of Memory
40 **SALVADOR DALÍ** — Soft Construction with Boiled Beans (Premonition of Civil War)
42 **SALVADOR DALÍ** — Giraffe on Fire
44 **SALVADOR DALÍ** — Dream Caused by the Flight of a Bee Around a Pomegranate, a Second Before Waking up
46 **PAUL DELVAUX** — Dawn Over the City
48 **MAX ERNST** — Approaching Puberty or The Pleiades
50 **MAX ERNST** — The Elephant of Celebes
52 **MAX ERNST** — Loplop Presents a Flower or Anthropomorphic Figure with Shell Flower
54 **MAX ERNST** — The King Playing with the Queen
56 **ALBERTO GIACOMETTI** — Man and Woman
58 **PAUL KLEE** — Room Perspective with Inhabitants, 1921, 24
60 **WIFREDO LAM** — The Jungle
62 **RENÉ MAGRITTE** — The Key to Dreams
64 **RENÉ MAGRITTE** — The Door to Freedom
66 **RENÉ MAGRITTE** — Time Transfixed
68 **RENÉ MAGRITTE** — The Empire of Lights
70 **ANDRÉ MASSON** — The Villagers
72 **MATTA** — Year 44
74 **JOAN MIRÓ** — Stars in the Sexual Organs of Snails
76 **JOAN MIRÓ** — Collage
78 **JOAN MIRÓ** — Woman
80 **MERET OPPENHEIM** — Fur Breakfast
82 **PABLO PICASSO** — Composition with Glove
84 **PABLO PICASSO** — Woman in a Red Armchair
86 **PABLO PICASSO** — Corrida
88 **PABLO PICASSO** — Woman with Foliage
90 **MAN RAY** — Le violon d'Ingres
92 **YVES TANGUY** — The Dark Garden
94 **YVES TANGUY** — Day of Slowness

A new Declaration
of the Rights of Man

What is Surrealism? Searching for a definition in his "First Manifesto of Surrealism", published in 1924, André Breton resorted to the phraseology of dictionaries and encyclopaedias:

"SURREALISM, noun. Pure psychic automatism by which it is intended to express, either verbally or in writing, or otherwise, the true function of thought. Thought dictated in the absence of all control exerted by reason, and outside all aesthetic or moral preoccupations.

ENCYCLOPAEDIA. Philosophy. Surrealism is based on the belief in the superior reality of certain forms of association heretofore neglected, in the omnipotence of the dream, and in the disinterested play of thought. It leads to the permanent destruction of all other psychic mechanisms and to its substitution of them in the solution of the principal problems of life. Have professed absolute surrealism: Messrs. Aragon, Baron, Boiffard, Breton, Carrive, Crevel, Delteil, Desnos, Eluard, Gérard, Limbour, Malkine, Morise, Naville, Noll, Péret, Picon, Soupault, Vitrac."

This pseudo-scientific explanation, intended to throw more light on the art movement that Breton dubs "Surrealism", introduces yet another stylistic change to this rambling, disjointed manifesto, whose structure defies all logic.

On reading the names of those who, in Breton's estimation, represent "absolute Surrealism", we might imagine that this is a purely literary movement. However, in a footnote, Breton opens up this new domain to practitioners of the fine arts. He lists Uccello, Seurat, Moreau, Matisse, Derain, Picasso, Braque, Duchamp, Picabia, Chirico, Klee, Man Ray, Ernst and Masson as members of a group who, without having heard the "Surrealist voice" are nonetheless sympathetic to the cause.

Astonishingly, Breton names not only contemporaries but also previous generations, represented by Uccello, Seurat and Moreau – and Dante, Hugo and Chateaubriand in the field of literature – as if Surrealism were a fundamental intellectual position dating back centuries. However, a look at history will clearly show that, while there were always artists whose works were inspired by dreams, the supernatural, the irrational and the absurd, we can only understand the precise significance of Surrealism as an artistic movement if we see it in the context of a particular period, the years between the two World Wars.

1910 — Sigmund Freud publishes "Über Psychoanalyse" **1910 — Wassily Kandinsky paints his first abstract watercolour**
1911 — Marie Sklodowska-Curie receives the Nobel Prize for Chemistry for the isolation of radium

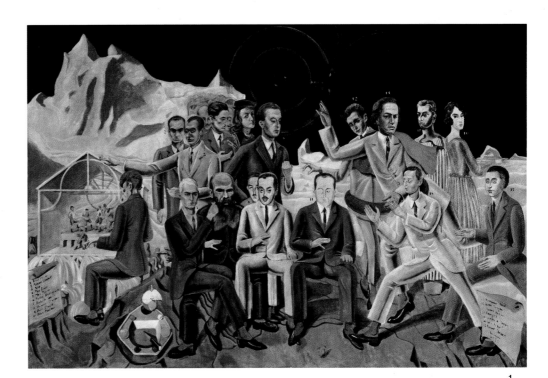

1. MAX ERNST
<u>Rendezvous of the Friends</u>
1922, oil on canvas, 130 x 195 cm
Cologne, Museum Ludwig

Persons depicted: 1. René Crevel, 2. Philippe Soupault, 3. Hans Arp, 4. Max Ernst, 5. Max Morise, 6. Fjodor Dostojewski, 7. Rafael Sanzio, 8. Théodore Fraenkel, 9. Paul Eluard, 10. Jean Paulhan, 11. Benjamin Péret, 12. Louis Aragon, 13. André Breton, 14. Johannes Theodor Baargeld, 15. Giorgio de Chirico, 16. Gala Eluard, 17. Robert Desnos

1

It was Guillaume Apollinaire who coined the term "surrealism" in 1917. He first used it in the programme for Erik Satie's ballet "Parade", also describing his own play "Les mamelles de Tirésias" (The Breasts of Tiresias) as a "surrealistic drama".

Critique of a saturated society

Apart from tracing the origin of the name, we also discover that two historic events were crucial to the birth of the Surrealist movement.

The artists who came together in Paris in the early 1920s shared a deep mistrust of materialistic, bourgeois society, which, they believed, was responsible for the First World War and its terrible aftermath. Not only that, but with its smug, superficial way of life and its belief in the omnipotence of technological and scientific achievement, society had succumbed to a process of degeneration to which the only answer was a revolutionary new anti-art. Already the Dadaists' anarchistic manifestations had attacked outdated ideas and those who clung relentlessly to them. The Surrealists shared some Dadaist ideas, but they set out to be better organised and more relevant to the real world. André Breton, the unifying figure and charismatic leader, who over the next two decades would co-ordinate activities and rally the troops, envisaged a movement that could really make a difference. Surrealism would not only embrace art and literature but would also play a part, as the "First Manifesto" put it, in "solving all the principal problems of life". It would affect every aspect of existence and bring about social and psychological change.

Central to this concept were the ideas of Sigmund Freud, which André Breton adapted to suit his own purposes. He regarded Freud's findings as the fortuitous rediscovery of the power of dreams and imagination that had long lain hidden behind the purely rational outlook that predominated at the time. Now, Breton predicted, the psyche would come into its own. A new intellectual tendency would evolve and artists could develop a perspective enabling them to free themselves from the control of reason. Sigmund Freud's contribution had been to define and describe the subconscious mind as a genuine phenomenon that governed human thought and behaviour. Breton translated this understand-

1911 — The Norwegian Roald Amundsen becomes the first man to reach the South Pole
1912 — Guillaume Apollinaire coins the term Orphism **1912 — First Futurism exhibition outside Italy in Paris**

> "The simplest Surrealist act consists in going into the street with revolvers in your fist and shooting blindly into the crowd as much as possible. Anyone who has never felt the desire to deal thus with the current wretched principle of humiliation and stultification clearly belongs in this crowd himself with his belly at bullet height."
>
> André Breton

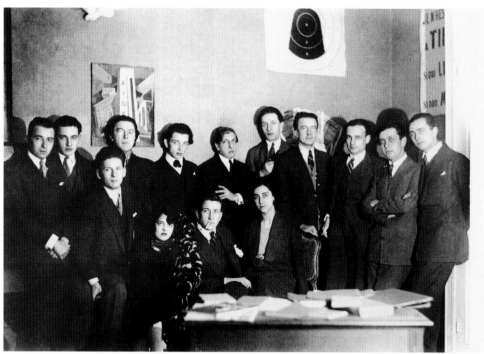

2

ing into an artistic and literary methodology, based on the subconscious and the imagination which, he believed, had been repressed by rationalism, civilisation and progress. Breton used Freud's theories to inspire those willing to fight against a culture that he saw as threatened by the censoriousness of the super-ego.

In 1916, while working as a junior doctor in the neurology department of a hospital in Nantes, Breton met Jacques Vaché, whose anti-bourgeois attitudes were expressed through his profound admiration of the playwright Alfred Jarry and his nonsensical Dadaist antics. Breton, meanwhile, took a special interest in and kept records of the dreams and thought processes of mental patients. After Vaché's suicide in 1919, Breton and Philippe Soupault began work on a series of texts based on the technique of "free association", which was published later the same year under the title "Les champs magnétiques" (Magnetic Fields). This is now regarded as the first-ever manifestation of *écriture automatique*, described by Breton in the "First Manifesto": "Completely occupied as I still was with Freud at that time, and familiar as I was with his methods of examination which I had some slight occasion to use on some patients during the war, I resolved to obtain from

myself what we were trying to obtain from them, namely, a monologue spoken as rapidly as possible without any intervention on the part of the critical faculties, a monologue consequently unencumbered by the slightest inhibition and which was, as closely as possible, akin to *spoken thought*."

The chance meeting of a sewing machine and an umbrella on an operating table

The significance of the method of "automatic writing", so often mentioned in the same breath as Surrealism, is far more symbolic than practical. To the writer, *écriture automatique* stands for the need to allow creativity to feed on the deepest levels of the unconscious, on dreams and hallucinations, and at the same time to exclude rational thought as far as possible. Those engaged in the fine arts introduced practices, which, according to the medium used, plumbed new, non-rational sources of inspiration for creativity. In his 1934 treatise "What is Surrealism?" Max Ernst recalled how hard it was in the beginning for painters and sculptors to find

1912 — The luxury liner "Titanic" sinks on her maiden voyage from Southampton to New York after colliding with an iceberg

1913 — The world's first domestic refrigerator is sold in Chicago

PARENTS !

racontez vos rêves à vos enfants

15, rue de Grenelle, Paris-7e

2. MAN RAY
"Bureau for Surrealist Research"
In the premises of the "Surrealist Centre", rue de Grenelle, Paris, December 1924
From left to right (standing): Charles Baron, Raymond Queneau, Pierre Naville, André Breton, Jacques-André Boiffard, Giorgio de Chirico, Paul Vitrac, Paul Eluard, Philippe Soupault, Robert Desnos, Louis Aragon; sitting: Simone Breton, Max Morise, Marie-Louise Soupault

3. BUREAU FOR SURREALIST RESEARCH
Surrealist flysheet (Papillon)

ways of working that corresponded to *écriture automatique* and to use the techniques at their disposal to achieve poetic objectivity, namely to banish reason, taste and conscious will from the creative process. Theoretical investigations were of no help; only practical experiments would do. Ernst described Lautréamont's "chance meeting of a sewing machine and an umbrella on an operating table" as a well-known, almost classic, example of the phenomenon discovered by the Surrealists, which involved bringing together two or more seemingly incompatible objects on an incompatible surface. This could provoke "the most powerful poetic detonations". Countless individual and collective experiments had proved the usefulness of this procedure. It had also become clear, said Ernst, that the more arbitrarily the elements were brought together, the more dramatic and poetic the results.

A typical example of this process is collage, of which Max Ernst was the principal exponent. As early as 1919, when the artist was still a leading light among the Cologne Dadaists, he discovered the hallucinatory effects of combining graphic elements from different contexts. Clippings from department-store catalogues, anatomical diagrams and old etchings provided the raw materials for his collages. He cut them up, re-mixed them and presented surprising combinations against a new background. Replying to demands for a purely technical definition of collage, Ernst wrote in "What is Surrealism?" "While feathers make plumage, glue does not make collage." For him, the process went far beyond the realm of the visual. It was a paradigm of the Surrealist mind set. "A ready-made reality, whose naïve purpose seems to have been fixed once and for all (an umbrella), finding itself suddenly in the presence of another very distant and no less absurd reality (a sewing machine) in a place where both must feel out of their element (on an operating table), will, by this very fact, escape its naïve purpose and lose its identity; because of the detour through what is relative, it will pass from absolute falseness to a new absolute that is true and poetic: the umbrella and the sewing machine will make love. The way this procedure works seems to me to be revealed in this very simple example. A complete transmutation followed by a pure act such as love will necessarily be produced every time that the given facts – the coupling of two realities which apparently cannot be coupled on a plane which apparently is not appropriate to them – render conditions favourable."

1913 — The premiere of Stravinsky's ballet "The Rite of Spring" in Paris provokes a scandal
1913 — The "Armory Show" – the first great international exhibition of modern art – takes place in New York **1914** — Outbreak of war in Europe

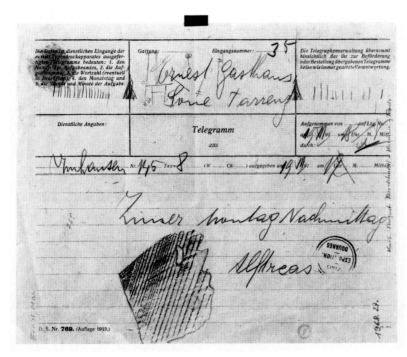

4

"Led by the great light, Max Ernst was the first
to make the new appear and in his early pictures,
to take on the great adventure: every individual
depends as little as possible on the other …"

André Breton

In 1936, when Max Ernst expressed these thoughts on collage in his essay "Beyond Painting", he also recognised in retrospect how important the technique of mixing objects and ideas had been to the artistic and intellectual development of Surrealism. Collage had succeeded in making irrationality part of every branch of art, poetry and even science and fashion. With the help of collage, he said, the irrational had found its way into our private and public life. Without collage, the Surrealist film would have been unimaginable. Moreover, its influence on the further development of Surrealist painting, especially the works of Magritte and Dalí, should not be underestimated.

In 1925, Max Ernst discovered frottage, an activity popular with children which, like collage, allowed plenty of room for the unexpected in the creative work of the artist. It involved rubbing a pencil or almost-dry paintbrush on paper or textile placed over an object with an uneven surface, revealing the texture of the underlying object. The use of this technique is referred to in the creation of *Histoire Naturelle* (fig. 6). Writing over a decade later in "Beyond Painting" (1936), Ernst was as enthusiastic as he had been about collage. Frottage was a semi-automatic process that intensified the painter's visionary capabilities and had a more marked effect on the image produced than the conscious, active intervention of the artist, he said. "My curiosity being aroused and struck with amazement, I came to use the same method to question all sorts of materials that happened to enter my visual field: leaves and their veins, the ravelled edges of a piece of sacking, the knife-strokes of a 'modern' painting, a thread unwound from a spool of thread, etc." These in turn revealed "human heads, animals, a battle that ended with a kiss". The rubbing process intensified the artist's mental capacity while blocking off all conscious controls such as reason, taste or morality and restricting to the minimum the active role of the person who would once have been called "creator".

A "Bureau for Surrealist Research"

The Surrealists' activities were not confined to literature, poetry and the fine arts. Shortly before the publication of the "First Manifesto of Surrealism" in 1924, the Bureau for Surrealist

1915 — Einstein formulates his General Theory of Relativity
1916 — Birth of the Dada movement at the Cabaret Voltaire in Zurich

1916 — Heavy fighting around Verdun

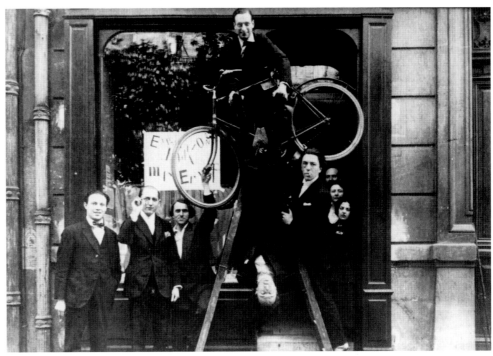

4. MAX ERNST
<u>Telegram from Tristan Tzara to Max Ernst</u>
19 July 1921 (front and reverse)
Frottage, pencil on paper, 18.5 x 22 cm
Basle, Kunstmuseum, Kupferstichkabinett

5.
<u>"Dada Max Ernst"</u>
Opening of the exhibition in the Galerie au Sans
Pareil, Paris, 2 May 1921
From left to right: René Hilsum, Benjamin Péret,
Serge Charchoune, Philippe Soupault, Jacques Rigaut
(head down), André Breton

5

Research opened in the rue de Grenelle in Paris and later placed the following revealing advertisement in the "La Révolution surréaliste", the Surrealist journal that also began publication in 1924. "The Bureau for Surrealist Research using all appropriate means aims to gather all the information possible related to forms that might express the unconscious activity of the mind." The description in Louis Aragon's essay "Une vague de rêves" underlines the fact that this was an initiative aimed at putting Surrealism to practical use: "We've hung a sculpture of a woman from the ceiling of an empty room, where every day worried men, bearers of heavy secrets, happen by … The visitors, whether born in faraway climes or on our doorstep, contribute to the elaboration of this formidable war machine designed to kill and help decide what can and cannot be achieved. At 15 rue de Grenelle, we have opened a romantic refuge for unclassifiable ideas and single-minded revolts. Whatever hope lives on in this desperate world will turn its last delirious gaze toward our pathetic little shop. Somehow we must put together a new Declaration of the Rights of Man."

The people who formulated the idea of comprehensive social renewal appear in a group photograph taken by Man Ray in December 1924 (fig. 2). We see the Surrealists under the sculpture mentioned by Aragon, in front of a painting by Chirico.

Surrealism and painting

Giorgio de Chirico, whom Breton described in the 1924 manifesto somewhat ambiguously as "so admirable for so long", was one of the first painters to attract Breton's attention when the Surrealists broadened their initial focus on literature and poetry to include the fine arts. In 1925 Breton began publishing, in serialised form, a history of modern painting in "La Révolution surréaliste". He had come across Chirico while researching the connections between modern art and Surrealism, and single examples of the painter's early works had appeared in the magazine. Breton's attitude to Chirico turned to disapproval after the artist moved away from *Pittura metafisica*. Nonetheless, at least before he "fell from grace" by returning to a naturalistic style of painting, Breton was eager to get him on board with the Surrealists. He saw Chirico's work as fulfilling his main criteria for "Surrealism in paint-

1917 — Lenin and Trotsky prepare the communist Revolution in Russia **1918 — End of the First World War. Kaiser Wilhelm II of Germany is forced to abdicate** **1919 — Treaty of Versailles lays down terms of peace between Germany and the victorious allies**

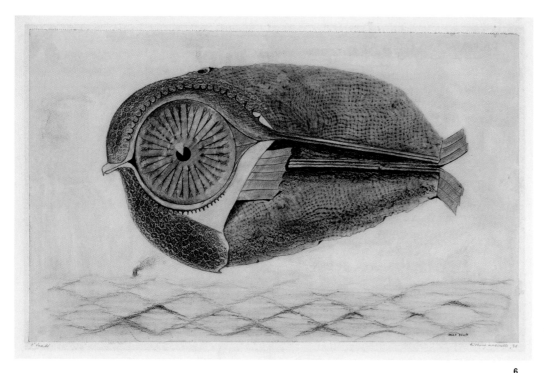

6. MAX ERNST
<u>L'évadé, Histoire Naturelle, sheet 30</u>
1925, frottage, pencil on paper, 26 x 43 cm
Stockholm, Moderna Museet

6

ing", a deliberate turning away from reality. Writing of Chirico, Breton said that the artist's greatest folly was to have strayed over to the side of an army laying siege to a city, which he himself had built and made impregnable. It would forever resist him as it has so many others with its terrible forces, for that is how he meant it to be. What happened there could not happen elsewhere. How often, Breton continued, had he himself tried in his imagination to find his way around those buildings and to picture the eternal sunrise and sunset of the spirit, the mysterious chronology of the colonnades, the ghosts, the lay figures and the inner spaces.

Mysteriousness and unreality were terms that could not necessarily be applied to Picasso, many of whose works appeared in "La Révolution surréaliste". Breton was careful not to call Picasso a Surrealist in so many words. But could not Picasso's work be seen as going beyond painting, thereby proving that there was such a thing as Surrealist painting? If Breton acknowledged that painting had the same powers of expression as language, if he recognised that a new direction had been forged from the moment the painter ceased to reproduce the external world and concentrate instead on his inner visions, was he not defining a wider framework for painting as a Surrealist statement? Obviously Breton was aware how significant Picasso's admittance to the Surrealist camp would be for the popularity of the movement. In his book "Surrealism and Painting", published in 1925, he commented in some detail on Picasso, writing with admiration of the artist's "rebelliousness" and of the studio in which "divinely unusual" figures were fashioned. While some had claimed that there could be no such thing as Surrealist painting, Picasso had lifted the spirit to its highest level, said Breton, going far beyond mere protest.

The Surrealists and the artists around them

From 1920 an array of artists began to congregate around the Surrealists in Paris. Max Ernst, who had initiated or taken part in numerous Dadaist activities in Cologne, showed his first collages 1921 at Galerie Au Sans Pareil (fig. 5). In his 1936 treatise "Beyond Painting" he described these works as "the miracle of

1919 — Leading German left-wing socialists Rosa Luxemburg and Karl Liebknecht are murdered by right-wing paramilitaries
1919 — The Bauhaus is founded in Weimar 1919 — Robert Wiene shoots "The Cabinet of Dr Caligari"

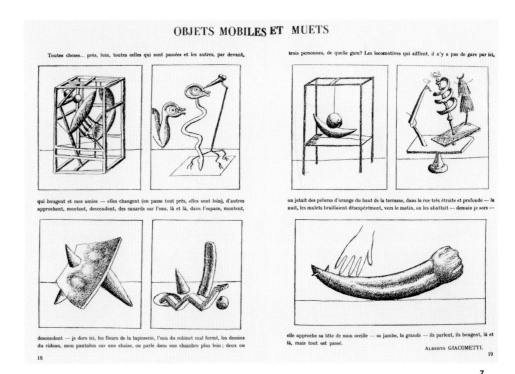

7. ALBERTO GIACOMETTI
<u>Moving and dumb objects</u>
In "Le Surrealisme au Service de la Révolution", December 1931

the complete transformation of living beings and objects, with or without change to their physical or anatomical form" – words that capture the surprising and, in the Surrealist sense, the mysterious nature of Ernst's creations. In the same year Max Ernst renewed contact with Paul Eluard, whom he had first met in Cologne, marking the beginning of a lasting friendship. Eluard acquired a series of early works from Max Ernst, who also painted important murals for Eluard's house in Eaubonne. Not only did the friendship between poet and painter survive a number of crises – Max Ernst travelled to Paris in 1922 on Eluard's passport and it was also thanks to Eluard that he was released from an internment camp in southern France at the beginning of the German occupation – but it also led to their collaboration on several Surrealist books, which sympathetically combined text and illustrations. The first of these, "Les malheurs des immortels" (Misfortunes of the Immortals), appeared in 1922. Further publications, like "Une semaine de bonté" (A Week of Kindness), followed in the 1930s, testifying to the deep mutual understanding between Max Ernst and Paul Eluard and the close connection between literature and painting in Surrealism.

There were also other notable friendships, like that of the painter Yves Tanguy and Marcel Duhamel, publisher of the "Fantômas" novels that were held in high esteem by the Surrealists. For some time Tanguy and Duhamel shared a small house on the rue du Château in Paris. With Duhamel's financial support, Tanguy was able to devote himself to his artistic career. In 1927, the works of this self-taught painter were exhibited at the Galerie surréaliste in Paris. André Breton wrote the foreword for the exhibition catalogue.

In 1922 Tristan Tzara, who in 1916 was one of the co-founders of the Dada movement in Zurich, was enthusiastically taken up by the Surrealists. Tzara collaborated with Man Ray on "Champs délicieux" (Delicious Fields), a book that brought together Tzara's text and Man Ray's "Rayographs". In 1921, Man Ray invented the process he called Rayography. This was a photographic method whereby the object to be photographed was placed directly on light-sensitive paper to create a kind of shadow picture.

André Masson met Breton in 1924 following the artist's first solo exhibition at the Kahnweiler gallery. Masson's *dessins*

--
1920 — Mahatma Gandhi begins his non-violent campaign for Indian independence from Britain 1922 — James Joyce publishes his novel "Ulysses" 1922 — Walther Rathenau is assassinated by right-wing fanatics during his first year as German Foreign Minister
--

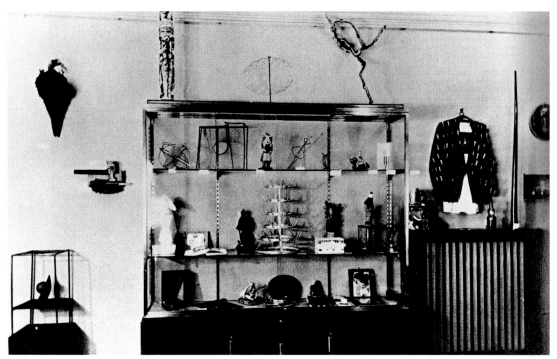
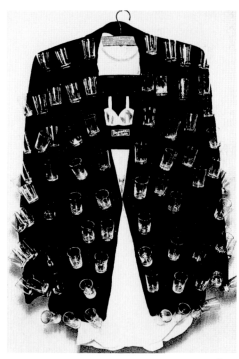

8

9

automatiques – a designation based on Breton and Soupault's *écriture automatique* – had already appeared in early numbers of "La Révolution surréaliste". Since the beginning of the 1920s, Masson had been one of a circle of friends which included Antonin Artaud, Robert Desnos and Michel Leiris, who met at his home on the rue Blomet. Next door to Masson's studio at 45, rue Blomet, was Joan Miró's apartment, as the two artists discovered quite by chance when they met at a party in 1923. "Masson was always a great reader and was full of ideas," said Miró recalling their friendship. "He was friendly with nearly all the young writers of the day. I came to know them through Masson ... I found them more interesting than the painters I met in Paris. I was spellbound by the new ideas they advocated and above all by the literature they talked about. I spent nights devouring their ideas."

Some of the Surrealist painters and photographers were represented at an exhibition held from 14 to 25 November 1923 at the Galerie Pierre in Paris under the title "La Peinture surréaliste" (Surrealist Painting). They included Miró, Klee and Arp, as well as Picasso and Chirico. It was the first group event to focus on painting and bring together the work of the leading Surrealists.

They represented the first phase of Surrealism in painting as it took shape during its "heroic" period between the first manifesto of 1924 and the second, published in 1929.

The most important intellectual concept was automatism, the graphic counterpart of free association with words, which led to the "abstract surrealism" of Masson, Miró and Arp, in which biomorphic, soft forms predominated along with sometimes extraordinary textural qualities. By contrast, the Surrealism of Magritte, Tanguy and Dalí, painters who only joined the movement later, was characterised by dream paintings.

However, the common denominator between them was their visionary, poetic and metaphorical treatment of their subjects. The Surrealists did not paint non-representational pictures. All Miró's, Masson's and Arp's works, however abstract they may appear, always relate to or at least suggest a subject. These artists continually tried to work towards an internal image which was either improvised through automatism or represented an inner vision.

1922 — Mussolini is appointed prime minister by the King of Italy　　　　　　　　　　**1922 — Founding of the USSR**

1923 — Germany experiences hyperinflation: 1 dollar is worth 4.2 trillion marks

8. MAN RAY
"Exposition surréaliste d'objets"
View of the "Surrealist exhibition of objects" in the Galerie Charles Ratton, Paris, May 1936

9. SALVADOR DALÍ
Aphrodisiac Jacket
1936, dinner-jacket with liqueur glasses, shirt and Ascot-tie on clothes hanger, 88 x 79 x 6 cm
Private collection

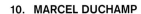

> "I have forced myself to contradict myself in order to avoid conforming to my own taste."
> Marcel Duchamp

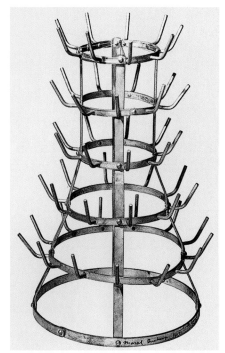

10. MARCEL DUCHAMP
Bottle Rack
1914, ready-made, galvanized iron, height 64 cm, Ø 42 cm
Paris, Musée National d'Art Moderne, Centre Pompidou

10

The "Rendezvous of the Friends"

A group portrait of the Surrealists entitled *Rendezvous of the Friends,* painted by Max Ernst in 1922 (fig. 1), shows the close contact between writers and painters, although the latter are less strongly represented in the picture. Along with Max Ernst himself, we see Hans Arp and Chirico, as well as a self-portrait of Raphael inserted like a piece of collage. Surrealist writers and poets are joined by Fyodor Dostoevsky, mentioned by Breton in the "First Manifesto", who appears as Raphael's literary counterpart. The subjects appear alienated, all of them looking in different directions with no contact between them. Johannes Baargeld appears to be taking long strides and making meaningless gestures, while Breton is behind him, staring straight at the spectator, his right hand raised as if bestowing a benediction on the group. Not least, this group portrait by Max Ernst, a snapshot of the year 1922, leads us to question how much cohesion there was between the various members and what it was that held them together.

Part of the answer to this question can be found in the Surrealists' many collective activities and their shared fascination with the same phenomena. They did things that always broke the usual bounds of existence, opening up areas of thought beyond rationality and reason, which were new, unknown and often funny. In 1926, they invented the game of *Cadavre exquis,* or "exquisite corpse" (fig. 22), rather like "consequences" in which several people are involved in creating a sentence or a drawing on one sheet of paper. As it passes from hand to hand it is folded over so that no player can see what his predecessor has done. The prototype gave the now classic game its name: the first sentence that came about in this way contained the words: "Le – cadavre – exquis – boira – le vin – nouveau" (The exquisite corpse will drink the new wine).

Parisian coffee-houses: venues of the first surrealist scandals

Although membership of the group continually changed and the Surrealists' fields of interest expanded from purely artistic or literary issues to politics and social problems, a constant fea-

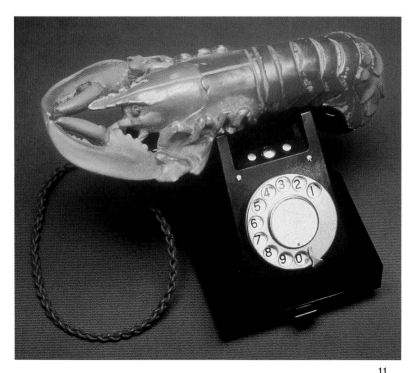

"Who would not rather be
more stupid through happiness than
more clever through damage?"

Salvador Dalí

11. SALVADOR DALÍ
Lobster Telephone or Aphrodisiac Telephone
1936, telephone with painted plaster lobster,
18 x 12.5 x 30.5 cm
Frankfurt a. M., Museum für Kommunikation

12. SALVADOR DALÍ
The Phenomenon of Ecstasy
In "Minotaure", December 1933,
photomontage, 27 x 18.5 cm
Private collection

13. SALVADOR DALÍ
Advertisement for the publication of the screenplay
"Babaouo"
Written by Salvador Dalí, 1932,
gouache and collage, 27 x 37 cm
Private collection

ture of the movement was the very specific group feeling of the Surrealists. Matta, who only joined the Surrealists in the 1930s, described this in a later interview. "We used to meet in the *Flore*," he recalled, "apart from us there was no one there – so it was always the same people. At that time we recognised that we were adopting a certain position. It wasn't that anyone demanded that one should behave in a certain way, like a guy who was out to destroy the whole structure of the bourgeois intelligentsia. It wasn't like that at all. It was much more that we were striving to achieve another kind of intellectual approach – a collective intellectual approach. The Surrealists had a strong group feeling – we worked out problems together. That was what was new."

The history of Surrealism gives the impression that certain subjects and issues always concerned the whole community. Whether it was about the case of Violette Nozière who murdered her father and whose cause was taken up by the Surrealists, or questions of sexuality or political commitment, or such phenomena as dreams, hallucinations and free associations, artists from every field always contributed ideas and works.

For its adherents, Surrealism was a way of life, a kind of existence that left room for playfulness and creativity. It was about living for the moment, with spontaneity and internal intellectual freedom and a lack of materialism, all of which were completely opposed to the values of the bourgeoisie. The Surrealists' preferred meeting place was the café. Their experiments in collective individuality took place in one of the typical big-city institutions that were the hallmark of the vibrant life of the French capital, anonymous and noisy, accessible to anyone at any time. The Surrealists met at the Café Certâ, at Le Petit Grillon in the Passage de l'Opéra or at Cyrano on the Place Blanche near Breton's apartment. The Cyrano had nothing in common with the artists' cafés in Montmartre and on the Left Bank, associated with Toulouse-Lautrec or Picasso's Blue Period. It was a favourite haunt of pimps, prostitutes, money-changers and drug-dealers who, like the Surrealists themselves, went there after seeing a show at the Grand Guignol on the other side of the street. The Cyrano attracted the Surrealists as a place on the margins of society where they could mingle with outsiders and eccentrics.

--

1926 — Fritz Lang shoots the film "Metropolis" **1927 — Charles Lindbergh makes the first solo Atlantic crossing by air**
1927 — The final part of Marcel Proust's novel cycle "A la recherche du temps perdu" is published

--

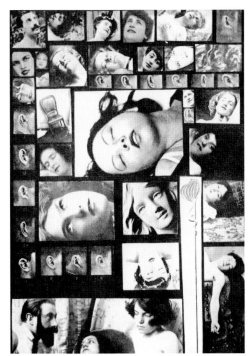

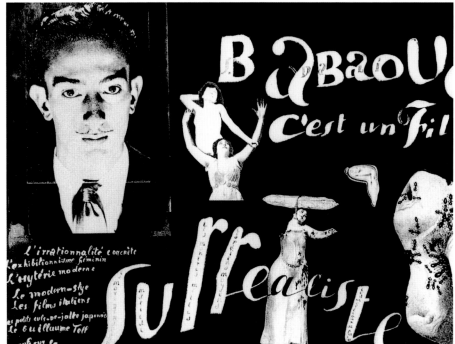

A café, the Closerie des Lilas on the Boulevard Montparnasse, was also the scene of one of the first scandals created by the Surrealists at the literary banquet of the "Mercure de France" in honour of the poet Saint-Pol-Roux on 2 July 1925. Tables were overturned, crockery trampled, the Surrealists screeched rousing slogans, blows were exchanged and windows smashed. A number of arrests were made.

On the day following these incidents, the committee of the *Société des Gens de Lettres* denounced the "scandalous behaviour of the Surrealists". They were also condemned by the committee of the *Association des Écrivains Combattants*, which declared they should be "held in contempt by the public" and critics vowed neither to mention their names nor to write the name of any movement ending in "ism".

The incident itself is characteristic of the Surrealists' anarchistic and anti-bourgeois attitudes. Their actions were an attack on established bourgeois order, designed to undermine all that was generally accepted and revered by respectable society.

Parents, tell your children your dreams

By 1925 these largely Dada-inspired activities were abandoned in favour of a new agenda which was more political and more closely attuned to reality. The first step along the road was the foundation of the Bureau for Surrealist Research, although at first the bureau was mostly concerned with intellectual and literary matters. It was from here that the famous Surrealist *papillons* (fig. 3) were distributed. These "butterflies" were small, brightly coloured handbills with headlines such as "Parents, tell your children your dreams" and "If you love love, you'll love Surrealism" which quickly became famous all over Paris. To the bourgeoisie whose value system was being called ironically into question, these imaginative and entertaining activities did not represent any real affront. This was the view expressed by the Surrealist writer Pierre Naville in his reflections on the socio-political relevance of Surrealism.

Precisely because the Surrealist campaigns operated on the level of "morality" the social classes under attack could be sure that the manifestations of Surrealism would never be enough

1928 — Alexander Fleming discovers penicillin **1928 — Premiere of Kurt Weill's "Threepenny Opera" with libretto by Bertolt Brecht**
1929 — The Wall Street crash triggers a world economic crisis

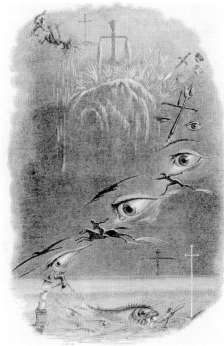

14

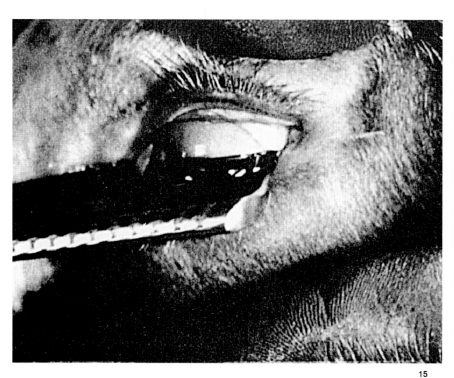

15

**"Give me two hours a day of activity,
and I'll take the other twenty-two in dreams."**

Luis Buñuel

to destroy social or even moral values. There were only two alternatives – to persist with a negative, anarchistic attitude or steer decisively towards a revolutionary path, the path of Marxism. "La Révolution surréaliste" contemplated collaboration with the Communist periodical "Clarté" and in the late 1920s there were those among the Surrealists who had a definite involvement with Marxism.

All the members of the movement either approved of Marxism or at least stood on the political left. The word "revolution" in the title of the magazine "La Révolution surréaliste" was nothing to do with the Russian Revolution. The meaning was quite different and in many respects completely the opposite, for individuality was much more important to the Surrealists than communality. The new, political orientation naturally led to tensions within the group, predictably causing a crisis because of the contradictory tendencies within the movement, whose aim, according to Breton, was to give spontaneous expression to the intellectual relationship between artists working independently. However, a group that carried out psychological and literary experiments, that published manifestos on current issues, that produced books and

magazines, that organised rallies and staged art exhibitions could not really be said to work spontaneously. It needed a central organisation and must ultimately insist on an official intellectual stance.

"Leaving aside matters of detail, personal problems and incompatibility of opinions and capabilities which are bound to occur between individuals and which become even more acute between groups, it appears that at the moment it is possible to define a general intellectual position from which many of our activities derive, and also to see the danger that it might quickly and fundamentally change." So said Naville in his 1927 essay "Mieux et moins bien" (Better and Worse), which advocated co-operation with the Communist Party. Breton responded, claiming that Communism failed psychologically because it sought to persuade people to act, spurred on by the hope of a better life in the future. "There is not one of us who would not be happy to see power taken out of the hands of the bourgeoisie and handed over to the proletariat," he wrote in "Légitime défense" in 1926. "Meanwhile, however, it is just as necessary that our experiments relating to the interior life should

1929 — The Museum of Modern Art is founded in New York, the most important of its kind in the world 1929 — Luis Buñuel
and Salvador Dalí shoot the film "Un chien andalou" 1930 — The showing of Dalí and Buñuel's film "L'Âge d'or" in Paris triggers a riot

"Fortunately, somewhere between chance and mystery lies imagination, the only thing that protects our freedom, despite the fact that people keep trying to reduce it or kill it off altogether."
Luis Buñuel

16

continue, without any control from outside, including from the Marxist side."

Given the divergent individual points of view within the group, Breton's attacks on a number of Surrealist figures in his "Second Manifesto" of 1929 could not have been unexpected. Breton rejected poets and authors of the past, such as Baudelaire, Poe, Rimbaud and de Sade, previously seen as role models by the Surrealists. He also carried out a kind of purge and expelled, among others, Picabia, Tzara, Artaud, Soupault, Masson and Desnos from the movement. A meeting that Breton called at the Bar du Château in the rue du Château on 11 March 1929 to debate the fate of the exiled Trotsky was transformed into a courtroom drama in which the convictions of individual Surrealists were put on trial. Not only had Breton circulated a list of relevant questions to all those who sympathised with the group, but during the meeting he also read out in a condescending or offensive manner some of the answers given by absentees. The gathering degenerated into a discussion of the internal troubles of the Surrealist group, leaving unsolved the political question it had been called to debate.

Mysticism of the inanimate

The tone of Breton's "Second Manifesto", published in 1929, is so mystical and speculative it comes as no surprise that parts of the text are concerned with alchemy. Breton regarded himself as the heir to a tradition going back to Nicolas Flamel and the fourteenth-century alchemists. Now Surrealism was seeking the "philosopher's stone" that would enable the human imagination to "take brilliant revenge on the inanimate".

This change of direction launched the concept of the mystical qualities of inanimate objects that typified the later phases of Surrealism, so clearly expressed in Magritte's paintings. From the "revelation of the remarkable symbolic life of quite ordinary, mundane objects" which Breton demanded in the "Second Manifesto" – it was only a small step to the creation by the Surrealists of their own objects.

In 1936 an "Exposition surréaliste d'objets" (Surrealist Exhibition of Objects) took place at the Galerie Charles Ratton in Paris. The exhibition focused on the mystification of everyday things that the Surrealists constantly promoted, and presented

1932 — More than 6 million unemployed in Germany

1936 — The socialist Léon Blum becomes French prime minister. He introduces economic and social reforms such as the 40-hour week and paid holidays

17. BRASSAÏ
Pablo Picasso's studio at Boisgeloup by night
1932

17

extraordinarily complex configurations of unrelated objects. In a photograph of an installation at the exhibition (fig. 8) we see a showcase containing a series of disparate artefacts, bewilderingly arranged side by side. In the middle is Marcel Duchamp's *Bottle Rack,* an everyday object declared a work of art, created in 1914. To its left is a 1934 sculpture by Max Ernst and nearby Meret Oppenheim's *Fur Breakfast*, made in the same year as the exhibition, alongside African sculptures, *objets trouvés* and complicated wire constructions.

If we read Salvador Dalí's thoughts on single examples of these inventions and the Surrealist object in general, it becomes clear that in the 1930s the awakening interest in the object was closely bound up with a perplexing and convoluted Surrealist method – largely influenced by Dalí himself – of exploring the subconscious. In the December 1931 issue of the magazine "Le Surréalisme au Service de la Révolution", Dalí published a series of drawings introduced by an absurd but poetic classification system. For example, Dalí distinguished between the "symbolically functioning object" (of automatic origin), the "transubstantiated object" (affective origin) and "objects to project" (oneiric origin).

The first of these he described as "an object which lends itself to a minimum of mechanical functions and is based on phantasms and representations liable to be provoked by the realisation of unconscious acts. The realisation of acts, the pleasure of which is inexplicable, or which tell us about the false theories hatched by censorship and repression. In all cases analysed, these acts respond to clearly manifested fantasies and desires." Dalí's decidedly objective description of complex, puzzling and even absurd-looking objects finds its counterpart in a series of drawings of objects by Giacometti (fig. 7) which also appeared in the December issue of "Le Surréalisme au Service de la Révolution" accompanied by the artist's own dreamlike and poetic text. Here, too, the text and the visual images stood in strong contrast to each other, although in this case the text was the more bizarre.

Salvador Dalí's "paranoid-critical method"

Along with Alberto Giacometti and René Magritte, Salvador Dalí was one of the artists who shaped the Surrealist movement

1937 — Pablo Picasso's painting "Guernica" is shown in the Spanish pavilion at the Paris World Exhibition
1937 — "Degenerate art" exhibition held in Munich **1938 — Hitler annexes Austria to Germany**

18. PABLO PICASSO
"Minotaure"
15 February 1933, title-page of the first edition

19.
"La Révolution Surréaliste"
1929, cover of the magazine in which "Un chien andalou" appeared

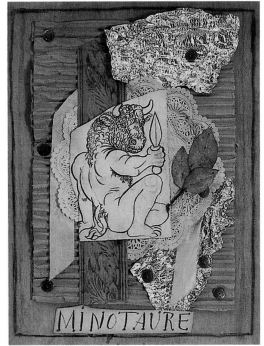

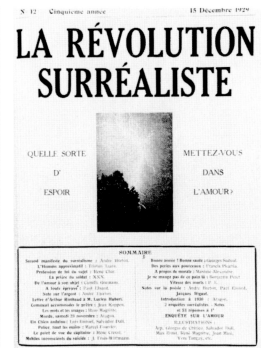

18 19

in the 1930s. His "paranoid-critical method" led to new departures in art, producing astonishing results, especially in the realm of the Surrealist object. Dalí's concept of critical paranoia made an important contribution to the mystification of the mundane. As André Breton put it: "The uninterrupted transformation of the object under the paranoiac's scrutiny permits him to regard the very images of the external world as unstable and transitory, if not as suspect, and it is, disturbingly, in his power to impose the reality of his impression on others." In Dalí's art, this power is expressed in what has been described as "three-dimensional colour photography of the superfine images of concrete irrationality entirely made by hand". Dalí had a unique way of observing and distorting the world around him that, as the photographer Brassaï recalled in a 1964 memoir, permeated reality with mysterious and previously undiscovered dimensions. Brassaï recounts how he and Dalí worked together on *The Phenomenon of Ecstasy* (fig. 12) and "involuntary sculptures" – bus tickets, screwed-up metro tickets, bits of soap and cotton wool, shaped by automatism.

Breton, too, had an innocent, unbiased and even distorted view of the real world. One of his greatest and most profitable

pleasures seems to have been rummaging around flea markets. He recalled one such expedition when he and his companion were impressed by a metal half mask – something they had never seen before. It occurred to Breton that this rigid object that seemed to serve no particular purpose might be a thing of noble lineage, the result of a romantic encounter between the helmet of a medieval knight and a velvet half-mask.

In his astounding and at times almost unfathomable paintings René Magritte also explored the enigmatic world of everyday things and the magical effect of placing familiar objects in new contexts, an effect that is not always obvious at first sight. His specific contribution lies in the realm of language, or rather the visual representation of his musings on the links between words and images. In the magazine "La Révolution surréaliste" in 1929, Magritte published a sequence of pictures to illustrate the particular problems arising from this relationship. The pictures were accompanied by captions such as "Some objects can do without a name" above a picture of a rowing boat, or "Sometimes a word serves only to designate itself" above the word "ciel" (sky) with a ring drawn around it, all of which engenders a feeling of unease

--

1938 — Government-inspired anti-Jewish pogroms in Germany lead to destruction of synagogues and Jewish-owned businesses on 9 November
1939 — Hitler unleashes the Second World War with the invasion of Poland. Great Britain and

--

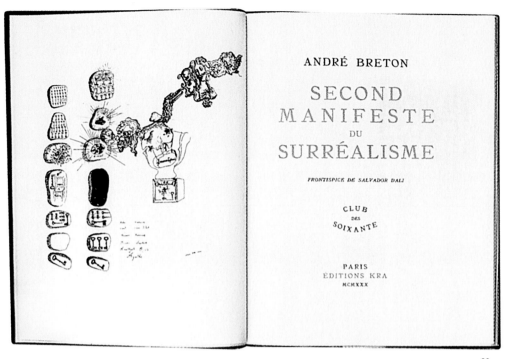

20. ANDRÉ BRETON
"Second Surrealist Manifesto"
1930, original edition
Paris, Bibliothèque Paul Destribats

21. ANDRÉ BRETON
Untitled (decalcomania)
In "Minotaure", June 1936, Indian ink on paper,
32 x 24.5 cm
Private collection

**22. YVES TANGUY, VICTOR BRAUNER,
JACQUES HEROLD**
Cadavre exquis
1934, pencil and collage on paper, 26 x 19.5 cm
Private collection

20

that goes beyond pure intellectual uncertainty. What is called into question is the assumption that calling an object by its name is tantamount to taking possession of it. Magritte questions how we can grasp, understand, order and control the world when we can no longer be sure what things are called. In his word-picture paintings he uses the sense of insecurity triggered by the incorrect, unaccustomed naming of objects to alert the spectator to the complexity and absurdity of normality.

"Minotaure"

"One afternoon when I went to see Picasso, I caught him composing the first cover for 'Minotaure' (fig. 18)," says Brassaï in "Conversations with Picasso". "He had made an unusually felicitous montage. With thumbtacks, he attached to a block a piece of corrugated cardboard, similar to the pieces he was also using for his sculptures. On top of it, he placed one of his prints depicting the monster, and around it he arranged ribbons, lace made from silver paper, and slightly faded artificial leaves, which, he confided,

came from an out-of-fashion hat Olga had thrown away. When this montage was to be reproduced, he was very insistent that the thumbtacks appear on it. It was under this splendid cover that, on 25 May 1933, the first issue of *Minotaure* appeared."

"At that time," Brassaï continues, "the Surrealist group was at a turning point. The 'First Manifesto of Surrealism' was already nine years old. The scandals, the excesses and the quarrels were things of the past. Gone were the hopeless despair, the anger and the regular sabotage. They no longer talked of memorable meetings to discuss *écriture automatique*, the hypnotic trances, the accounts of dreams which, as Breton hoped, would inspire all future poetry. In a matter of a few years the mysterious source they believed to be infinite and 'accessible to all' was exhausted. In 1933 Surrealism was no longer a wild rebellion but a successful revolution whose activists had achieved power. With a new sense of responsibility, André Breton and Paul Eluard were trying to consolidate the foundations of the movement. Brassaï felt that even if the Surrealist spirit could be kept going through 'Minotaure', it must nevertheless cast off the aggressive attitudes which had previously been the hallmark of Surrealism. This glossy

France declare war on Germany
and defeats France, imposing a ceasefire

1940 — Infringing the neutrality of Belgium, Luxembourg and the Netherlands, Germany invades
1940 — Leon Trotsky is murdered in Mexico

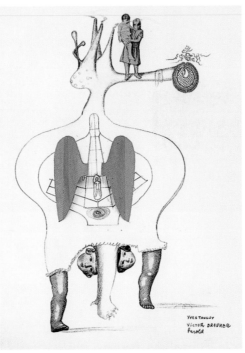

21 22

magazine whose print run was limited to 3,000 copies – 1,500 for further editions – was beyond the reach of proletarian purses and could only serve a milieu of rich, titled snobs, the first patrons and collectors of Surrealist works."

Brassaï's views about "Minotaure's" arrival in 1933 were borne out by the fact that "Le Surréalisme au Service de la Révolution" had been founded in 1929 superseding "La Révolution surréaliste", while the same year saw the publication of the first issue of Georges Bataille's "Documents". The 1930s witnessed an upheaval in the movement, epitomised by the contradictory nature of its two official organs. The one supported confrontational Surrealism while the other placed emphasis on Surrealism as an art movement engaged in ongoing research.

"Documents" provided a platform for an international debate that covered all artistic genres. Georges Bataille's numerous contributions appeared alongside articles by Carl Einstein and Georges Babelon. Leading specialists wrote on ethnography and medieval art, and there were articles on Paul Klee, Pablo Picasso and Karl Blossfeldt. It was not a simply a Surrealist journal but a publication whose style and range of topics would have

been unimaginable without Surrealism. But the magazine also represented a new Surrealist tendency. There were striking differences between "Documents" and "La Révolution surréaliste". The former's clearer page layout was a sharp contrast to the style of a purely informative scholarly journal, which "La Révolution surréaliste" consciously aspired to be. Also noticeable was the predominance of visuals, leaving poetry and literature fighting for space.

As well as the new-style Surrealist magazines, a new genre – Surrealist film – appeared on the scene in 1929 with the screening of Salvador Dalí and Luis Buñuel's "L'Âge d'or" and "Un chien andalou". "Un chien andalou" contains the famous scene in which a razor blade slices through an eyeball (fig. 15), an image that inspired Georges Bataille to write reflectively in "Documents" in 1929, "The eye, which Stevenson so exquisitely calls a 'cannibal dainty', is for us an object so disturbing that we will never bite it. The eye also occupies an elevated position in horror, being among other things the eye of the conscience. We are also well acquainted with Victor Hugo's poem, the obsessed and lugubrious eye, the living eye so terrifyingly dreamt

1941 — The United States enters the war
1942 — The Wannsee Conference discusses the organisation of the systematic extermination of Jews in German concentration camps

23.

23.
<u>"First Papers of Surrealism"</u>
October 1942, installation in the exhibition,
451 Madison Avenue, New York
Philadelphia Museum of Art,
Marcel Duchamp Archive, Gift of Jacqueline,
Peter and Paul Matisse

24.
<u>The Surrealists in Paris</u>
c. 1930, from left: Tristan Tzara, Paul Eluard, André
Breton, Hans Arp, Salvador Dalí, Yves Tanguy, Max
Ernst, René Crevel, Man Ray

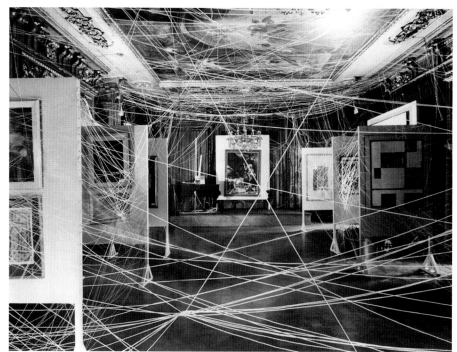

23

by Grandville in the course of a nightmare shortly before his death …" (fig. 14).

Surrealism –
Thought dictated in the absence of all control?

With Surrealism well into its second decade, Bataille here sums up the important aspects of Surrealism and the visual arts. Compared with other avant-garde movements of the first half of the twentieth century Surrealism was attempting to move beyond the definition of the visual image and its function. Physiological sight and the normal functioning of the eye are meaningless. Imagination and the ability to look inwards are crucial. In this sense the eye can be personified and behave like a nightmarish apparition. The act of seeing is subject to new conditions and so too is Surrealist art, which is the product of the inner voice, visual hallucination and dreams.

Decalcomania was one of the last manifestations of the Surrealist myth. This was a kind of printing technique that involved spreading paint onto a flat surface, pressing a piece of paper or canvas onto the coated area, and then separating the two. The resulting pattern could be altered, transformed into a new composition, or left as it was as a work of art in its own right. Whether the artist used paper for this new technique, as its inventor Óscar Domínguez did or, like Max Ernst, preferred canvas, the process raised serious questions about the role of chance and the unconscious. For in most cases the result of this process, related to collage and frottage, was not, as Max Ernst claimed in 1936 in "Beyond Painting", achieved without the artist's conscious intervention. As *écriture automatique* was to the realm of literature so collage, frottage and decalcomania were to the plastic arts. They represented a concept that could not be translated into reality, or at least not in the sense that Breton preached in the "First Manifesto", namely "thought dictated in the absence of all control exerted by reason, and outside all aesthetic or moral preoccupations". The methods the Surrealists chose to adopt in order to exclude rationality and reason from the creative process could only play an intermediary role. They could trigger associations, fantasies, and instinctive behaviour and could also include

1942 — The "First Papers of Surrealism" exhibition organized by André Breton and Marcel Duchamp is opened in New York
1943 — Uprising in the Warsaw Ghetto

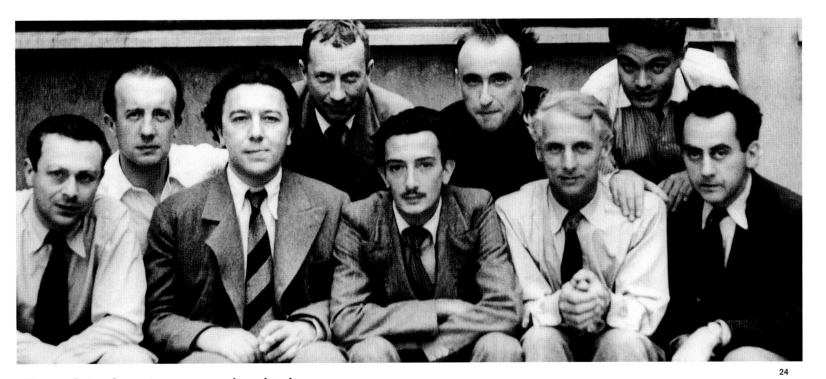

"The painter is not someone inspired, but one capable of inspiring others."

Salvador Dalí

chance. However, the artist always translated these phenomena into a work of his own invention.

The concept of opening up the subconscious made it possible to think differently and to analyse and undermine the "advanced civilisation" of which the Surrealists were so critical. In this sense, what Surrealism, and in particular Surrealist painting, achieved had less to do with technical innovation than with a new understanding of art. What mattered to the Surrealists was not the perfect, self-contained work of art, but the procedure through which it was created and the ideas it conveyed. This focus on the subject of a painting, the thinking behind it and not least its title, without which the work would be incomprehensible – we only have to think of Magritte – explains why the Surrealists attached such importance to the relationship between painting and literature. Surrealism saw itself as a movement embracing many artistic genres, a "thought factory" whose products were based on the attempt to address social, artistic or literary problems. It was a collective experience, which came to an abrupt end with the rise of Fascism and the outbreak of the Second World War, when many Surrealists were forced into exile.

After France capitulated, a number of them fled to the unoccupied zone, hoping to find their way to America. Supporters from the US got together to form the American Committee for Aid to Intellectuals. The organisation found accommodation for the refugees at a château near Marseilles and arranged their passage to the United States. Breton, Wifredo Lam, Masson and Claude Lévi-Strauss left for Martinique in Spring 1941. From there, Lam travelled onwards to Santo Domingo. The rest went to New York. In July 1941, Max Ernst also managed to leave for New York. By August 1941 Man Ray had already returned to the United States and soon afterwards settled in California.

By 1942 New York and its surrounding area had become the centre of Surrealist activity. It was a historically unique situation in which the Surrealists found themselves rubbing shoulders with other émigré artists like Chagall, Léger, Lipchitz and Mondrian. But it was impossible to recreate the atmosphere of Paris. They found it hard to keep in touch with one another. "We missed café life," Max Ernst later wrote. "We had artists in New York, but no art. One person alone cannot make art. It very much depends on being able to exchange ideas with others."

--

1944 — August sees the liberation of France by the Allies. Charles de Gaulle marches into Paris, which has remained undamaged

1945 — 8 May: Germany surrenders unconditionally **1945 — Atomic bombs dropped on Hiroshima and Nagasaki**

--

HANS ARP

Concrete Sculpture

1934, marble, 37 x 75 x 32 cm
Private collection

b. 1887 in Strasbourg,
d. 1966 in Basle

For several years Hans Arp developed his art against the backdrop of the Surrealist movement in Paris. In 1916, he was one of the group, which included Hugo Ball, Richard Huelsenbeck and Tristan Tzara, who founded the Cabaret Voltaire in Zurich. In 1919/20 he was in Cologne where he was closely involved with the Dadaists based in the city, especially Max Ernst. In 1924, the year in which André Breton's first Surrealist manifesto was published, Arp finally joined the Surrealist movement, taking part in the first Surrealist exhibition in 1925. On this occasion he showed only pictorial works, since he only began sculpting in 1931, shortly before the creation in 1932 of the Abstraction-Création group of which he was co-founder.

Arp's work could be described as standing between two poles – Surrealism and Abstraction. His early collages are simple and austere and mainly concerned with the exploration of form. Meanwhile, the playfully poetic titles of his work owe more to the traditions of Dada and Surrealism. Arp's working methods allowed room for the "law of chance" and intuition, and his spontaneous, constantly innovative, creative processes were very much in line with Surrealist thinking.

Another aspect of his Surrealist-inspired work was his interest in the metamorphosis of the female body, which led to the creation of sculptures recalling Picasso's and Miró's soft and infinitely changeable forms of the early 1930s. A typical example is *Concrete Sculpture (Sculpture concrète)* from 1934 in which a trunk, head and the rounded stumps of legs, which appear to have evolved naturally but in condensed form, capture the sensuous shapes of a female torso. Designed to be free-standing, it can be viewed from several different perspectives.

It has no obvious top or bottom, front or back, as if to underline the idea that it is still in the process of taking shape. Arp saw this process that he called "concretion" as a natural occurrence, as opposed to the creation of a form chosen by the artist, which is a human as distinct from a natural act.

Concrete Sculpture is part of Arp's continuing exploration of this theme. One of the earliest examples from a series of "configurations" in relief dating from 1927/28 reduces the female body to parts of the shoulders, waist, hips and tops of the legs. A key element in the composition is the strategically placed navel. For Arp this was a symbol of life and fertility, but it does not feature in his 1929 relief of Amphora Woman, which shows a small feminine figure in front of a streak of red.

As it draws level with the little female shape, the streak broadens into a wide bowl shape, a recurring motif in Arp's work. This can be interpreted either as a peaceful, feminine refuge from the turmoil of life, or as the belly of a pregnant woman sheltering the embryo.

**"The midnight hour of art is sounding.
The fine arts are being outlawed."**

Hans Arp

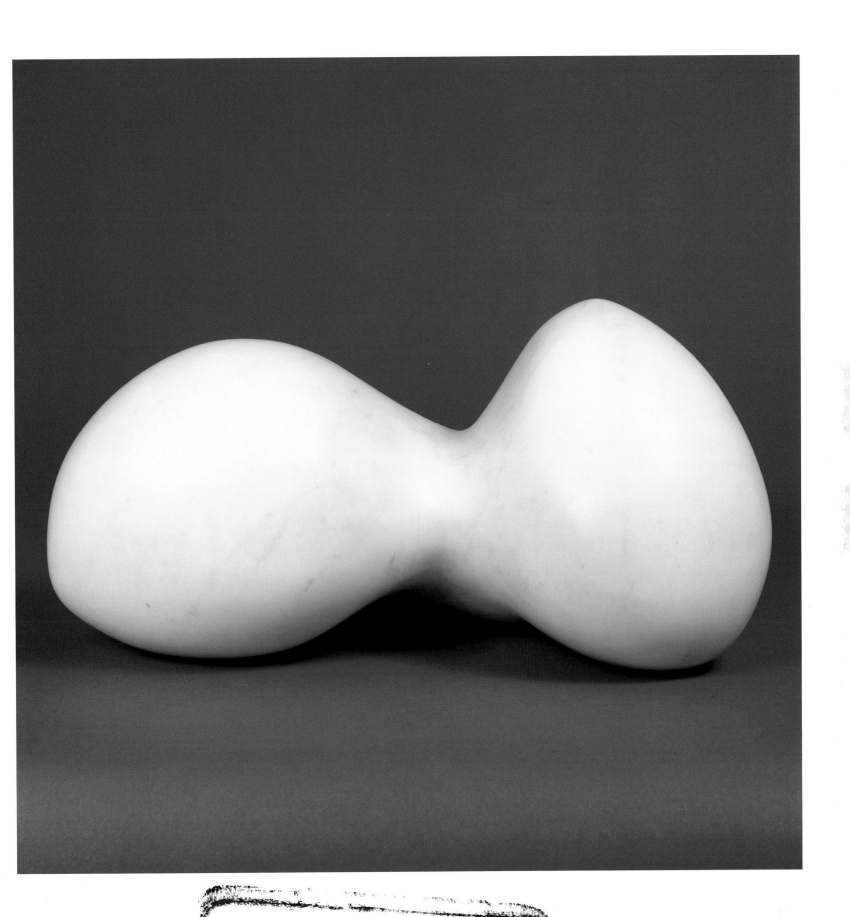

HANS BELLMER

The Doll

1932/1945, painted wood, hair,
socks and shoes, 61 x 170 x 51 cm
Paris, Musée National d'Art Moderne, Centre Pompidou

b. 1902 in Katowice, d. 1975 in Paris

Hans Bellmer created his first *Doll (Die Puppe)* in 1933. In the context of his artistic activities at the time, it was a unique and independent work, inspired by a variety of influences. With the rise of Fascism in Germany, Bellmer, who was then working as a graphic designer, decided to cease producing anything that could be of even indirect benefit to the state and to concentrate on his art. The doll was the result not only of that decision but also of Bellmer's meeting with his 15-year-old cousin Ursula. The artist was forced to resist the teenager's powerful erotic attraction and sublimated his desires in the creation of the doll.

In 1934, after the publication, at his own expense, of his essay "Die Puppe" (The Doll), Bellmer made contact with the Surrealists in Paris, prompted by an issue of the Surrealist magazine "Minotaure". Over the next few years he studied the works of Baudelaire, Lautréamont and Jarry, the Surrealists' great literary role models. Then, in 1938, following the death of his wife Margarete, he finally left Berlin to settle in Paris.

Bellmer's first doll was brought to life mainly in the form of photographs taken by the artist. It was the only way in which he could present his creation in the many different poses into which it could be manipulated. However, on a visit to Berlin's Kaiser-Friedrich-Museum, Bellmer saw an articulated doll from the age of Albrecht Dürer, which inspired him to equip his own dolls with joints. The versatility achieved in this way is crucial to the example at the Pompidou Centre. In the words of German art critic Wieland Schmied, the doll appears "as a mirror image with the ball-and-socket joint situated at the navel – a monster with two pelvises, two pairs of legs, two pairs of feet in small, black, patent-leather children's shoes and a superfluous head, at once the stuff of fantasy and frighteningly real, capable of change yet always the same, innocent and knowing, childlike and depraved, vampire and succubus, an articulated construction of enormous intensity and at the same time one of the most convincing sculptures of our age".

Bellmer's central idea was the eroticization of the body, a body which – according to characteristic Surrealist thought processes – even in its absurd distortions, always reflects the same basic sexual pattern. "I think that the different categories of expression – posture, movement, gesture, action, sound, word, visual imagery, arrangement of objects – are all born of the same mechanism, and that their origin displays a similar structure. The basic expression, insofar as it is not from the outset intended as communication, is a reflex. To what need, what bodily urge might it respond? ... The genitals project onto the shoulders, the leg naturally projects onto the arm, the foot onto the hand, the toes onto the fingers. And so a strange hybrid is created, of the real and the virtual, of what is permitted and forbidden to each of the two elements, of which the one acquires such reality as the other has forfeited."

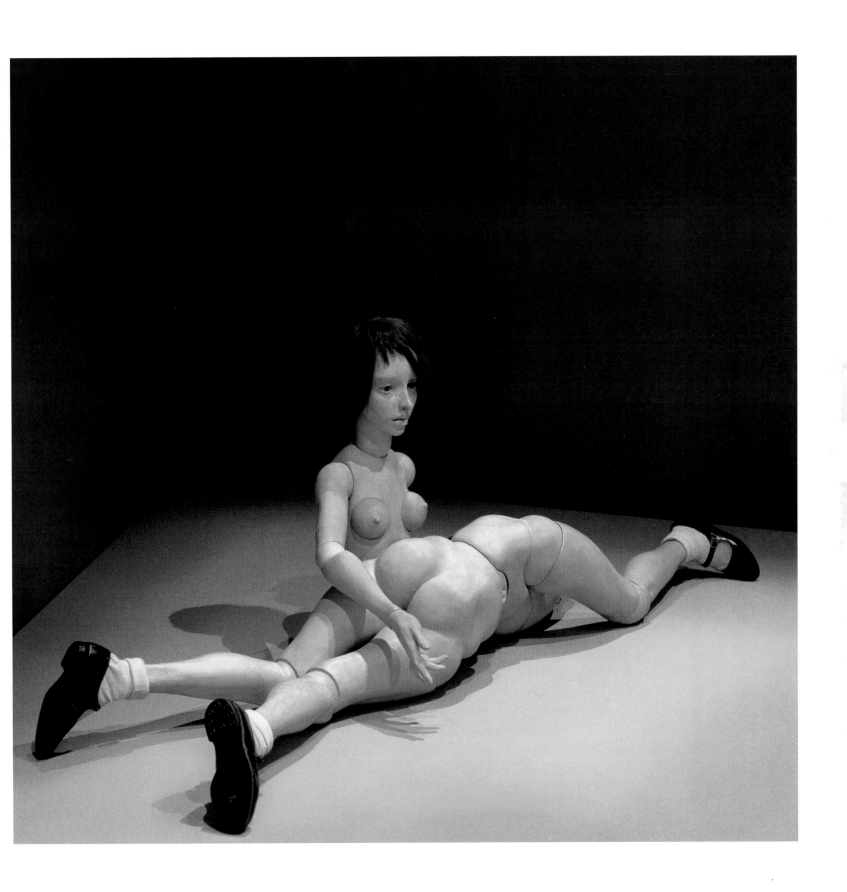

BRASSAÏ

The Image as Produced by Automatic Writing

1934, photograph
From "Minotaure", no. 5, May 1934

b. 1899 in Brasso (Hungary), today
Brasov (Romania),
d. 1984 in Beaulieu-sur-Mer (France)

The series of photographs by Brassaï (Gyula Halasz) *Paris by Night* and *Secret Paris* show that, as far as themes and atmosphere were concerned, his work already had much in common with Surrealism. However, it was only later, at the beginning of the 1930s, that he began working directly with the Surrealists. On several occasions Brassaï's photographs were used to illustrate Breton's essays in the magazine "Minotaure". One such was the abstract *Image as Produced by Automatic Writing (L'image, telle qu'elle se produit dans l'écriture automatique)*. The photo, whose title was intended as an allegory or symbol of "automatic writing", shows what looks like a feathery spider's web against a deep, dark background, which might be interpreted as electrically charged lightning against the night sky, or a plant floating in water. The fine fibres of the figure branch out in every direction and the image appears too complex, but at the same time too orderly, to be the work of a human hand – even when free of all rational control, which is the assumption behind automatic writing. Thus, a natural phenomenon is transformed into an image encapsulating notions of the irrational, the fortuitous and the uncontrolled, which were central to Surrealist thinking.

Similar ideas inspired a series of photographs entitled *Sculptures involontaires* on which Brassaï and Dalí worked together. The subjects are everyday bits and pieces that have been subjected to involuntary manipulation – torn bus tickets, rolled-up Metro tickets, carelessly screwed-up bits of paper, pieces of soap or squashed cotton wool. Photographed in extreme close-up and lit to magical effect, these mundane objects acquire an air of mystery. The unconscious process they have undergone seems to imbue them with a life of their own.

Light plays a crucial role in making Brassaï's photos so effective. The semi-darkness that dominates his shots engenders the same mysterious atmosphere and feeling of uncertainty that Surrealist artists deliberately set out to create. At first, any similarities with the Surrealist vision in Brassaï's photographs were purely unintentional, as he made clear in an anecdote recounted in conversation with Picasso. André Breton asked the photographer for some night-time shots of Les Halles, the Paris flower market, and the Tour St. Jacques to illustrate his poem "La nuit de tournesol" (Night of the Sunflower). Breton's poem and Brassaï's illustrations appeared first in "Minotaure" and then in Breton's book "L'Amour fou" (Mad Love). But these photos were not, as Breton assumed, taken especially for him. Brassaï revealed that they had been in his possession for some time. They included an image of the Tour St. Jacques exactly as Breton described it "sous son voile pâle d'échafaudages" – "beneath its pale veil of scaffolding".

Rolled-up bus ticket, 1932

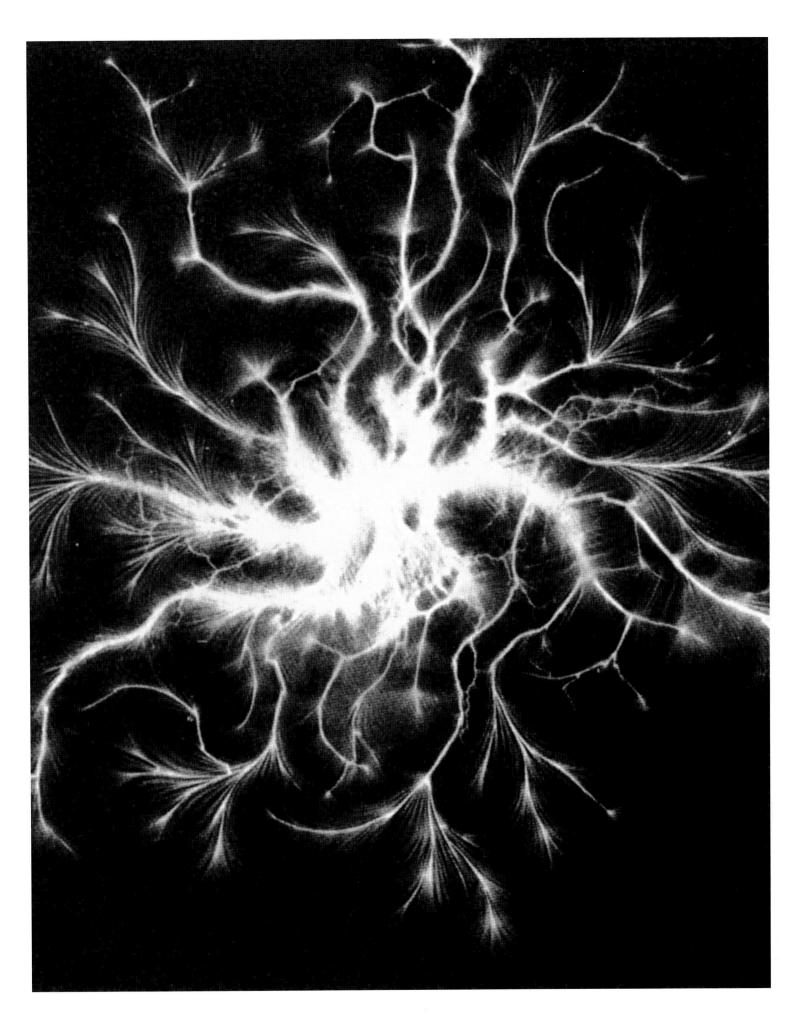

GIORGIO DE CHIRICO

Mystery and Melancholy of a Street

1914, oil on canvas, 87 x 71.5 cm
Private collection

**b. 1888 in Volos (Greece),
d. 1978 in Rome**

Deep silence reigns over the scene that Giorgio de Chirico opens up before us. We can almost hear the little girl's soft footsteps as she makes her way through the arcades and into the square, bowling her hoop along in front of her. Absorbed in her play, she seems oblivious to the heavy atmosphere and the ominous signs that surround her. What is the meaning of the circus wagon standing open like a trap? Whose is the shadow cast across the square? Who is hiding in the darkness of the long arcade?

"In the years from 1913 to 1917 Giorgio de Chirico disdainfully refused to be enslaved by outward appearances as most of his contemporaries were, including innovators such as Matisse and Picasso. His mind schooled in the ways of the Presocratics and Nietzsche, he was only willing to respond to the secret life of things ... Such painting, which only records those external aspects that evoke an air of mystery or that radiate some premonition, will inextricably unite the art of fortune-telling and actual art. It inspires foreboding and works by means of shock." André Breton's description of Chirico's painting during the period from which *Mystery and Melancholy of a Street (Misterio e malinconia di una strada)* dates, which appears in "L'Art magique" (Magic Art), published in 1957, not only explains Chirico's style (idiosyncratic, concise, devoid of detail or illusionism; it also casts light on his recurring use of the same forms, objects and buildings.

Chirico paints emotions, enigmatic, all-pervasive moods, largely inspired by his intensive study of Nietzsche in 1910 and 1911. Both the titles of his paintings, always revolving around words like "melancholy", "mystery", "dream" or "meditation", and his repertoire of forms appear to be interchangeable, since they do not refer to a real situation but serve the painter as theatrical props as he constructs an imaginary space in which we the spectators come face to face with ourselves.

If we accept Breton's interpretation, we encounter here long-hidden thoughts, experience the shock of recognition of images and dreams that lie buried in the unconscious. The image of the little girl running through the empty streets of an abandoned city is a particularly apt one in relation to recollections of childhood experiences. However, in most works from this period, Chirico uses symbols with more general meaning than this particular figure.

His many melancholy, mysterious squares and streets are constructed from deep, harsh shadows and surrounded by arcades. Although deserted, they are eerily "inhabited" by statues, most frequently by classical-style female sculptures that allude to a sleeping figure of Ariadne in Rome. In 1912, the artist portrayed *Melancholy* in a painting of the same name. Built of marble, an echo of a bygone age, the sculpture nevertheless appears more human and intimate than the endlessly repetitive rows of cold, shadowy arcades surrounding it.

"… the work of art must have neither reason nor logic. In this way it approaches the dream and the mind of the child."
Giorgio de Chirico

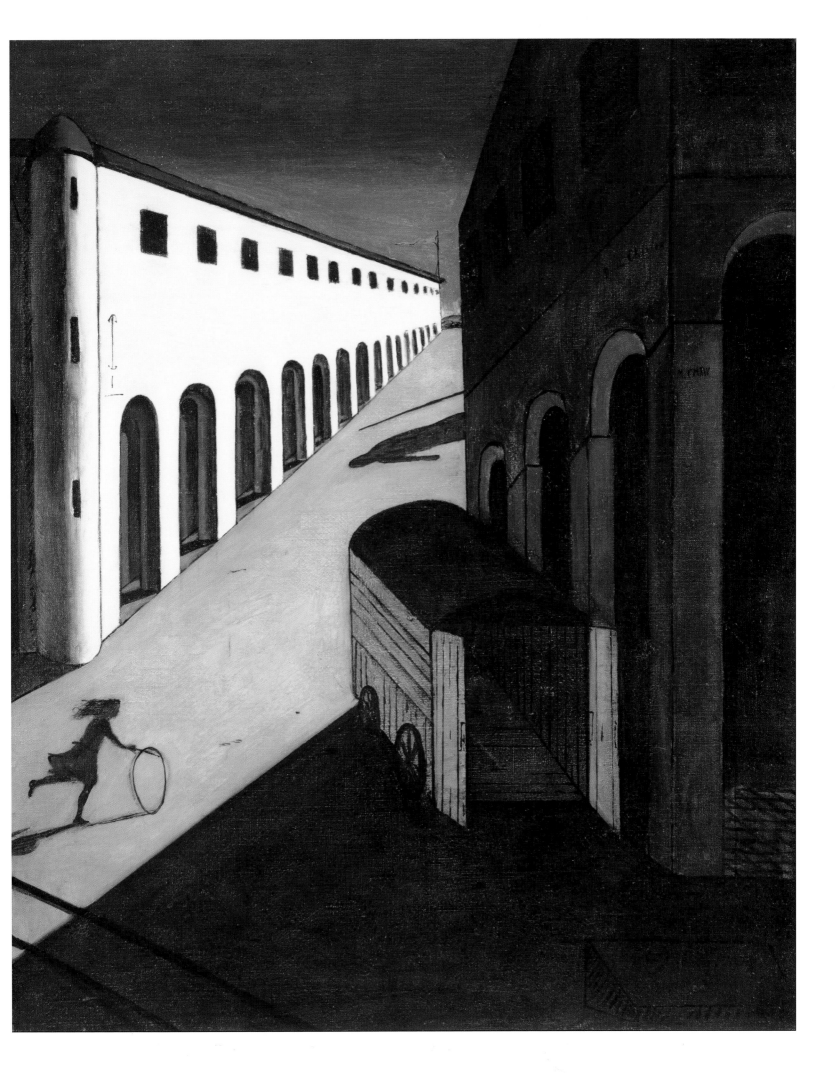

GIORGIO DE CHIRICO

The Disquieting Muses

1917, oil on canvas, 97 x 66 cm
Milan, Private collection

"It used to be that painters were mad and picture-buyers clever. Now the painters are clever and the picture-buyers mad."
Giorgio de Chirico

By 1912, along with statues and monuments Giorgio de Chirico had begun to introduce other figures into the lifeless atmosphere of his paintings. These were huge marionettes, whose anonymity and physical shape recalled both shop window dummies and the lay figures used by artists for anatomical studies. These beings, without arms and sometimes with hinges, nails and strings, sometimes supported by complicated devices, are completely without identity and function merely to convey a mood. We are reminded not only of the mechanised people in Francis Picabia's Dada works, but also of the Cubist deconstruction of the human figure, with which Chirico became intensely involved in Paris, largely through his close association with Guillaume Apollinaire and Pablo Picasso.

The concept of the world as a stage on which an absurd and meaningless puppet show was played out, an idea that drove Chirico's "metaphysical" paintings from the very beginning, becomes even more meaningful with the introduction of these fragile jointed figures. In Chirico's own words: "In the face of the increasingly materialist and pragmatic orientation of our age … it would not be eccentric in future to contemplate a society in which those who live for the pleasures of the mind will no longer have the right to demand their place in the sun. The writer, the thinker, the dreamer, the poet, the metaphysician, the observer … he who tries to solve a riddle or to pass judgement will become an anachronistic figure, destined to disappear from the face of the earth like the ichthyosaur and the mammoth." From this, we can conclude that Chirico thought the world had become meaningless and that people no longer felt entitled to try to make sense of it.

His representation of *The Disquieting Muses (Le muse inquietanti)* makes this abundantly clear. They are pictured in the city of Ferrara in front of the former residence of the Este family, whose members were great patrons of the arts. Significantly, this urban palace near which Chirico lived during the First World War, is forced to hold its own behind a rising stage alongside industrial buildings, factory chimneys and a silo. The rust-red, fortified building looms up against the backdrop of a turquoise-blue sky. At the front of a stage broken up by areas of deep shadow are the two muses – featureless lay figures in classical garb. One standing, the other seated, they are placed among a series of props. These include a red mask and a staff, allusions to the traditional attributes of Melpomene and Thalia, the muses of tragedy and comedy. Meanwhile, Apollo, leader of the muses, is represented as a statue on a pedestal in the background. He looks as subdued and lifeless as the muses. The spectator has to wonder where he will lead them, given the deeply melancholic state of his headless companions.

The Two Sisters, 1915

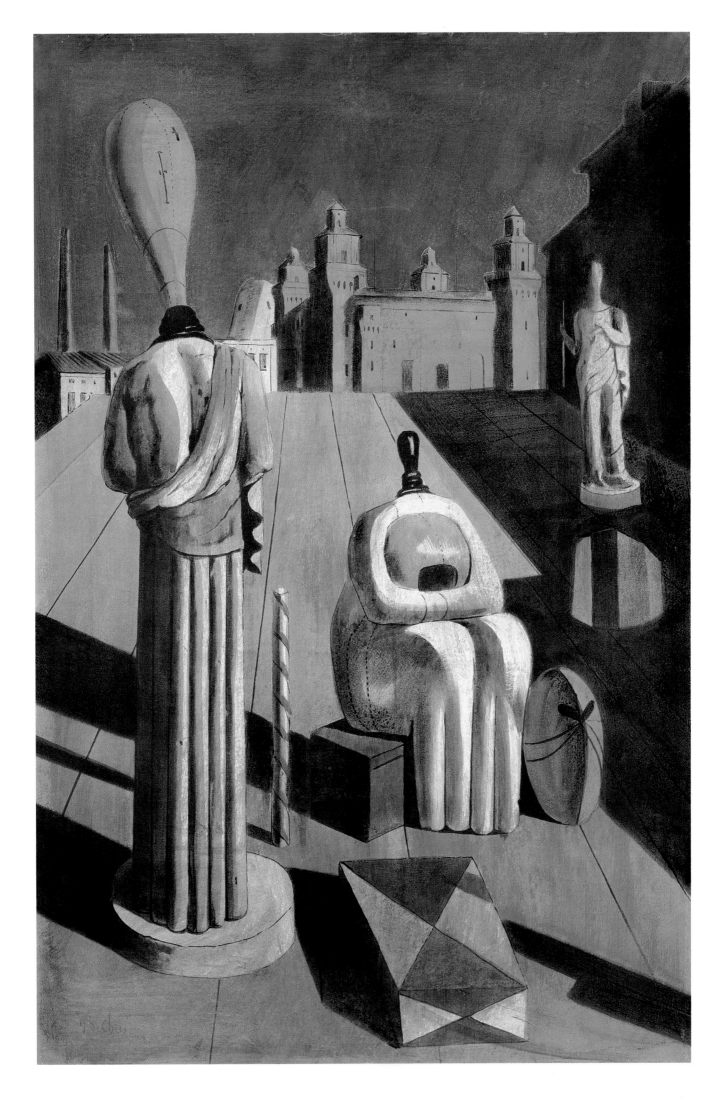

The Enigma of Desire – My Mother, my Mother, my Mother

1929, oil on canvas, 110 x 150 cm
Munich, Pinakothek der Moderne

b. 1904 in Figueras (Spain),
d. 1989 in Figueras

One way to approach Salvador Dalí's works is to understand that the stuff of which they were made was the product of the artist's own psyche. From it he deliberately fashioned paintings that appear irrational, enigmatic and complex. It therefore comes as no surprise that Dalí himself features in many of his compositions either as a hidden figure or a distorted face.

We spot one such self-portrait in *The Enigma of Desire – My Mother, my Mother, my Mother (L'énigme du désir – Ma mère, ma mère, ma mère)*. Dalí's head lies on the ground with eyes closed, seemingly asleep or half-dead – the ants streaming out of his ear suggest decomposition and decay – while the monstrous body, which takes up virtually the whole picture, seems to oppress and paralyse the painter. It is a strange object, whose indeterminate shape resembles that of an embryo capable of further development, but which also recalls a rigid geological formation. The painter is the prisoner of this body covered with oval cavities in each of which appear the same two words – "ma mère" (my mother). They are the key to the meaning of the painting and are complemented by a further seminal element, the little lion's head, its face twisted into a grimace. It seems to represent the father who clings, as if in triumph, to the highest point of the mountainous body, apparently pressing his son's face to the ground.

The lion's head reappears above Dalí's self-portrait as part of a complex group of figures. We also see the dejected, grizzled head of an old man in the sentimental embrace of a youth with his back turned to us. Nearby is a fish head on which sits a grasshopper holding in its hand a knife, threateningly raised, and the head of a woman – perhaps the mother – her face a picture of despair as she observes a scene she cannot comprehend. The aggressive lion and the white-haired old man seem to be the two faces of the father. He runs away from his son, who clings to him in fear, oblivious to the dagger the father clutches behind his back. Perhaps he wants to protect his son and defend him from the monsters, fish and spiders that surround him. Whichever way we put together and interpret the details of the picture, the deeper meaning of the work always seems to lead back to the suffering, seemingly paralysed face of the central figure, the artist himself. "How can he escape?" we want to ask. At which point, through one of the holes in the body in the centre of the painting, we catch sight of the naked, blood-covered upper body of a young woman, half-hidden in a grotto-like space. Almost like something out of a fairy tale, this female figure seems to hold out the prospect of release, enabling the enslaved creature lying on the ground to free himself from the shackles of fear and obsession.

> **"It is not me who is the clown, but this monstrously cynical and so unconsciously naïve society, which plays the game of seriousness in order better to hide its madness."**
>
> Salvador Dalí

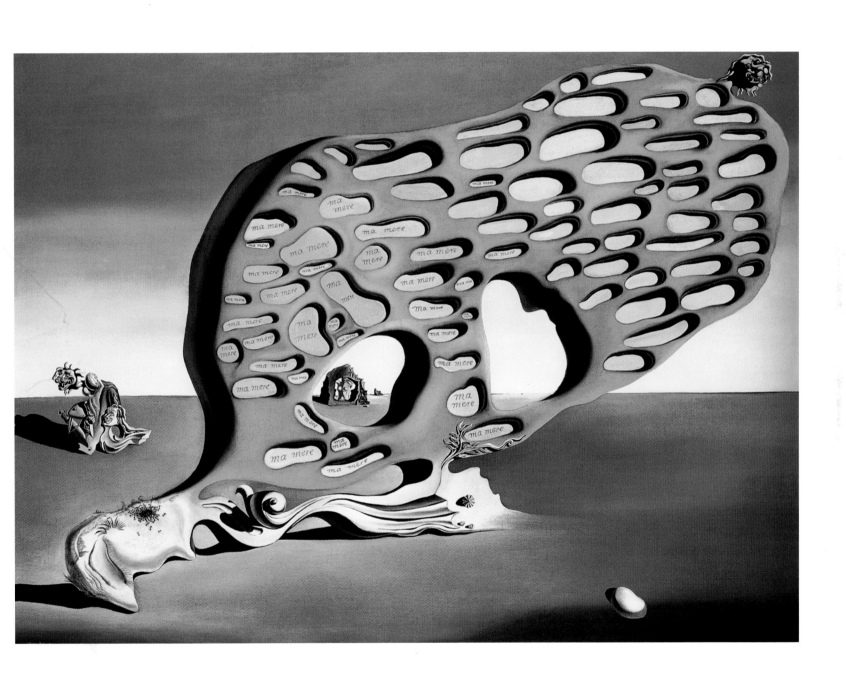

SALVADOR DALÍ

The Persistence of Memory (a. k. a.: Soft Watches or Time Slipping Away)

1931, oil on canvas, 24.1 x 33 cm
New York, The Museum of Modern Art,
Given anonymously. Purchase. 162.1934

The Persistence of Memory (*La persistance de la mémoire*) is a work in which many characteristics of Salvador Dalí's painting come together. In the distance is the rocky coastline of Port Lligat. Against a multi-level background several motifs are juxtaposed, amazing the spectator because of their total incongruity and bizarre appearance.

The painter's portrait in the foreground resembles a snail creeping along the ground, its body like a trail of colour vanishing into the dark sand. In the foreground are three soft watches, one gold, two silver; they appear soft, one snuggling close to the snail-like body, one draped over the branch of a leafless tree and the third hanging over the edge of the projecting section of a wall. The only clock that seems to have retained its normal consistency is painted a meaty red and is being devoured by the ants that have collected on its surface.

Not only the physical characteristics of the composition, but also its colours and coherence are subverted in Dalí's painting. The indicators of time – which form the real subject of the painting – undergo a far-reaching transformation almost impossible to grasp through the use of logic. It is not the forward movement of the watch hands but the melting of the watches themselves that shows that time is slipping away. The ravages of time are also symbolised by the dissolving snail, the painter's self-portrait. Meanwhile, the red watch besieged by ants and the skeletal tree on the far left of the picture are premonitions of approaching death. Do these intimations of mortality refer to the lifeless head and liquefying body of the painter lying on the ground? Is the picture about his unconscious fear of death or the *Persistence of Memory* that paralyses him?

In his memoirs, in which Dalí tells at some length how the painting came into being, he does not go into its symbolic content. He goes so far as to claim that its enigmatic meaning and unconscious content were hidden even from him. In "The Secret Life of Salvador Dalí" he describes how, after a dinner concluded with a very soft Camembert, he remained alone at the table contemplating the cheese and pondering the philosophical problem of "supersoftness". As was his habit, he then went to his studio to take a final look at the painting on which he was working at the time. It was a landscape near Port Lligat. The cliffs lay in a transparent, melancholic twilight and in the foreground stood an olive tree, with branches chopped off and no leaves. He knew that the atmospheric landscape he had managed to create would serve as background for an amazing picture, but he had not the slightest idea what it would be. As he went to turn off the light he suddenly "saw" the solution – three soft watches, one of them hanging pitifully from the branch of the olive tree. Although suffering from a splitting headache, he eagerly prepared his palette and set to work.

"Soft clocks are nothing other than paranoid-critical, tender, extravagant camembert abandoned by time and space."

Salvador Dalí

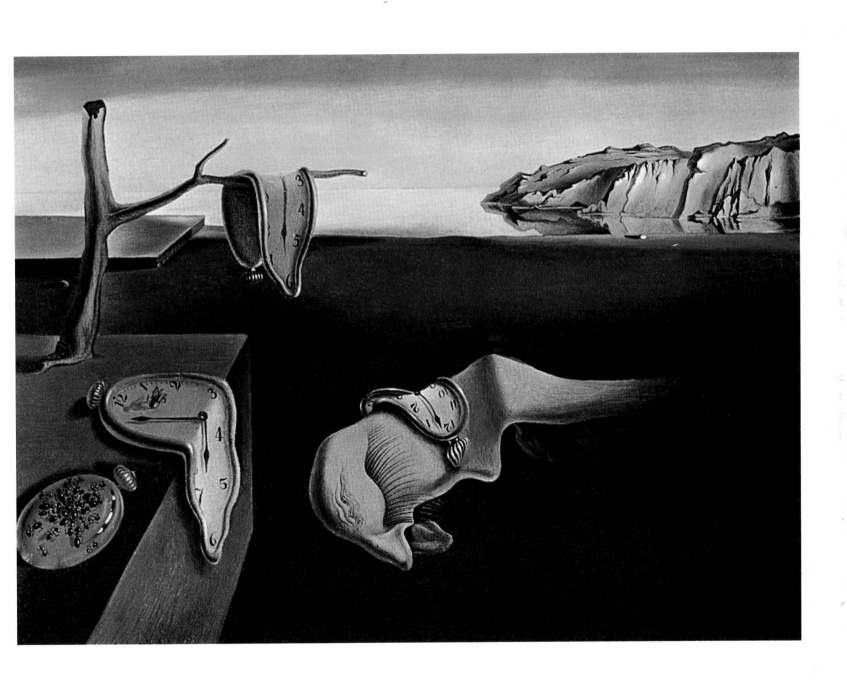

SALVADOR DALÍ

Soft Construction with Boiled Beans (Premonition of Civil War)

1936, oil on canvas, 51 x 78 cm
Philadelphia, The Philadelphia Museum of Art,
The Louise and Walter Arensberg Collection

Around the mid 1930s some of the titles of Salvador Dalí's paintings had obvious political connotations. One such example was *Soft Construction with Boiled Beans (Premonition of Civil War)*. Describing himself as "a painter of internal paroxysms", Dalí told how he painted his "premonition" six months before the outbreak of the Spanish Civil War. The picture featured "a vast human body breaking out into monstrous excrescences of arms and legs tearing at one another in a delirium of autostrangulation," which he then "embellished with a few boiled beans".

How is it possible to appreciate the political dimension of a painting that displays the same characteristics as many other "apolitical" works of the same period? The picture itself – a construction of human limbs, supported by a fossilized foot and a gnarled hand resting on a small chest of drawers – provides no information. Occupying the entire canvas, the structure stands in the bay of Port Lligat. In the background, banks of clouds move across an ominous sky. A man's face, riddled with pain, tops the construction, whose unbearable internal tension contrasts with the apparent lack of connection between the individual elements. This painfully irreconcilable, and at the same time completely inorganic relationship between the various body parts can in fact be interpreted as a metaphor for the Civil War, which the artist sees as a fateful catastrophe rather than an historic event. This point of view corresponds with the apolitical attitude that Dalí displayed throughout his life. His anarchism, dressed up as snobbery, led him to analyze social and political situations so as to exploit them in his own painting. For example, the glorification of Adolf Hitler, for which the Surrealists condemned Dalí, sprang not from admiration of the dictator and his political propaganda, but from what the artist saw as the Hitler's aesthetic and erotic appeal. Dalí often used political allusions to heighten the scandalous effect of his paintings. Speaking of references to Hitler and Fascism in his work he said: "I was fascinated by Hitler's soft and fleshy back, always so firmly laced up in his uniform ..." Dalí's apparent exaltation of Fascism led to a clash with André Breton and finally to Dalí's exclusion from Surrealist circles. In alluding to contemporary events, Dalí sought the wonderful and bizarre and the neurotic, in the widest sense of the word, choosing to tackle clearly political themes for purely aesthetic reasons. This was at a time when the Surrealists as a group were debating whether to take a direct political stand on the side of the Communists, or to continue to limit themselves to isolated, purely artistic activities.

It was an attitude that Dalí in no way shared. Ultimately his works, with their virtuoso painting and inexhaustible wealth of imagination and subject matter, were always a glimpse into his inner world. In his own words: "My whole ambition where painting is concerned consists in materializing mental images of concrete irrationality with the power-craziest precision ..."

Study for "Soft Construction ...", 1935

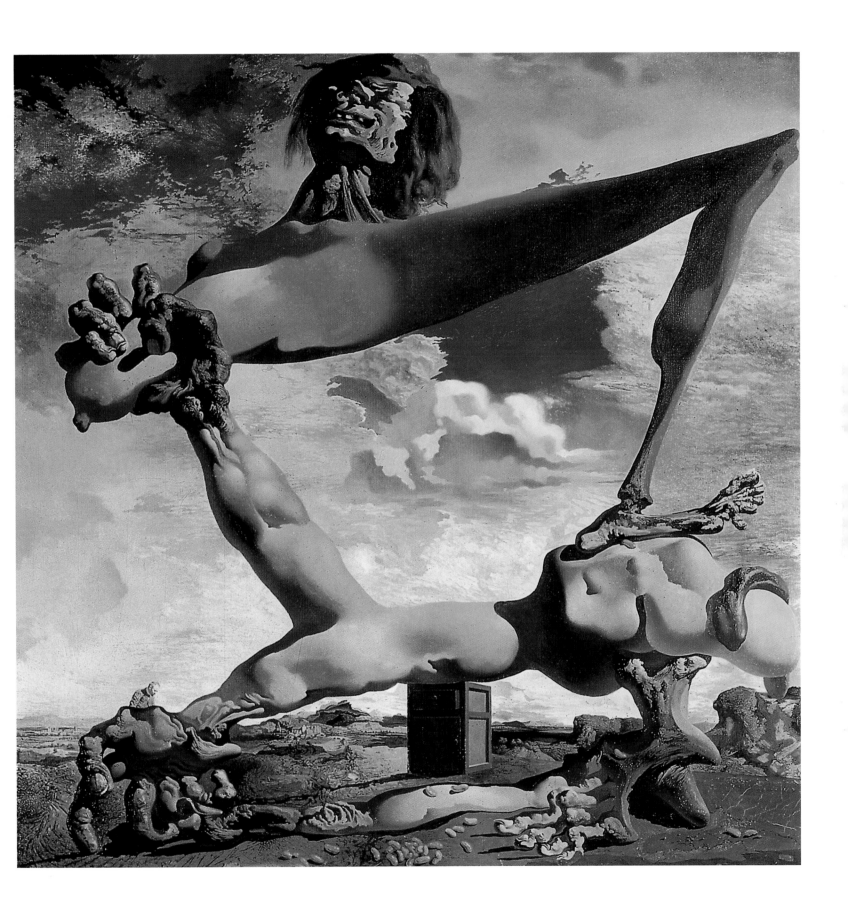

Giraffe on Fire

1936, oil on wood, 35 x 27 cm
Basle, Kunstmuseum Basel,
Emanuel-Hoffmann-Stiftung

"I think I am, in what I create, a rather mediocre painter. What I regard as brilliant is my vision, not what I actually create."
Salvador Dalí

The famous motif of a human body fitted with drawers crops up several times in Salvador Dalí's 1936 paintings. The most provocative example is a copy of the Venus de Milo, which Dalí equipped with drawers at belly, breast, head and knee level, with coquettish fur pom-poms for handles. By manipulating the ancient statue, the epitome of classical beauty, admired and alluded to in European art from the Middle Ages to modern times, Dalí not only downgrades it to an object but questions its very nature. What is at issue here is not so much the concept of beauty embodied by the Venus de Milo as the Surrealists' theory that the idealistic, balanced and harmonious version of beauty represented by the statues of Antiquity was no longer valid.

Behind the beautiful surface lurked unsuspected, confusing and terrifying things. This line of thought continues with the image of the drawers, suggesting that what lies beneath in the human psyche can be made accessible and visible.

The traumatic nature of such an idea is clear to see in *Giraffe on Fire (Girafe en flammes),* dating from the same year as *Venus de Milo with Drawers.* The classic white of the statue has changed to an intense dreamy blue, the colour of night, covering not only the sky but also the two female figures, moving slowly along with eyes closed, as if sleepwalking. Their thin, bony bodies are hampered by drawers, unnatural protuberances and crutches, and only with difficulty can they grope their way forward. The balanced contrapposto of the Venus de Milo has made way for a unwieldy figure engaged in a balancing act, struggling to maintain equilibrium in the knowledge that she is loaded down by the mysterious contents of the drawers.

Only with the aid of crutches can the figures stay upright, struggling blindly at the mercy of the night which, we assume, is intended as an allegory. It stands for the "other" side of human beings, for the unconscious and inaccessible regions of the self which cannot be controlled by reason but which nevertheless dictate our lives.

We cannot see where we are going, or what drives us. We live in a world that has become alien to us. Perhaps we may interpret the burning giraffe as a symbol of the absurdity of human existence in the modern world. As Wieland Schmied writes in "Salvador Dalí. Das Rätsel der Begierde" (Salvador Dalí. The Enigma of Desire): "Unlike man, in animals nature is still as it should be. Their animal being appears indestructible. The giraffe that simply bursts into flames is at one with the elements. Without thought and without passion it can surrender to the flames and be destroyed by them. The realm of nature, minerals and the elements will endure, as will animals. By contrast, man is subject to time, age and impermanence whose ravages can be seen in the faces, hands and movements of the sleepwalkers in the painting."

Venus de Milo with Drawers,
1936/1964

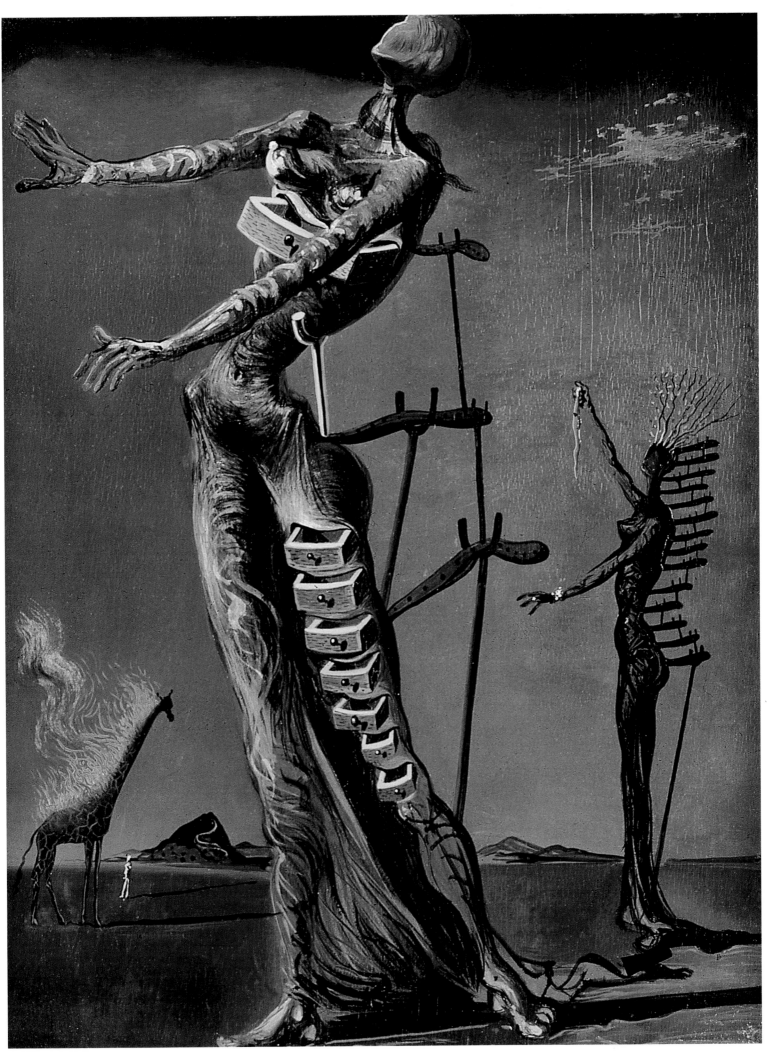

SALVADOR DALÍ

Dream Caused by the Flight of a Bee Around a Pomegranate, a Second Before Waking up

1944, oil on wood, 51 x 40.5 cm
Madrid, Museo Thyssen-Bornemisza

At the centre of this complex and brilliantly executed dream painting *Dream Caused by the Flight of a Bee Around a Pomegranate, a Second Before Waking up (Rêve causé par le vol d'une abeille autour d'une grenade, une seconde avant l'éveil)* is Dalí's wife Gala. Is she the dreamer or is she part of the painter's – or the spectator's – vision? Both the spatial construction of the picture and its complicated chronology make it hard to find a meaningful answer to the fundamental question the work poses.

The stretched-out, naked body of the sleeping Gala hovers above a rocky promontory. The glistening blue surface of the water in the background looks supernaturally still, as if to reinforce the magical silence of the dramatic happenings in the sky. A fish leaps out of a pomegranate and from its gaping mouth emerge the head and forepaws of a tiger. From the maw of the beast a second tiger springs. The line of its body, ready to attack and aimed straight at the sleeping woman, is extended to form a rifle armed with a bayonet, the point of which is about to stab Gala in the upper arm. In her dream, the genuinely threatening bee sting of the title becomes a symbolic stab wound, which the mind can connect with many other ideas and images.

In his painting Dalí not only captures the unreality of the dream but also encapsulates its complexity. The painter enables us to experience the multifaceted event in a single moment. The sleeping woman awakens from a dream lasting only seconds imagining she has seen a long, multi-layered and complicated film. Likewise the spectator is aware of the painting's peculiar chronology. In the space of a moment a series of monsters too complicated to describe in words appears above Gala's head. At the same time an elephant with extraordinarily long, insect-like legs strides across the horizon bearing an obelisk. It is a distorted image of a real work of art, Bernini's famous elephant statue in Rome, which somehow fits into the strange logic of the dream. At the same time, we see in the foreground an echo of the main event in the shape of a pomegranate encircled by a bee.

To some extent, this is the painter's own interpretation of the picture which he disguises as part of the dream, in the same way that medieval painters hid the meaning of their works behind allegorical references. Extraordinarily well-versed in the history and tradition of European painting, Dalí shows the pomegranate floating between two dewdrops, an allusion to the pearls of Venus, and casting a shadow in the shape of a heart – a fertility symbol. The connection between the pomegranate and the phallic symbolism of the series of aggressors striking out against the sleeping woman seems to be a reference to the relationship between Dalí and Gala, whose importance as the artist's muse, lover and adviser is well known. Dalí extends the spatial and chronological structure of the work so as to make it clear that it is he who has created both the dream and the masterly painting.

"The difference between me and the Surrealists is that I am a Surrealist."
Salvador Dalí

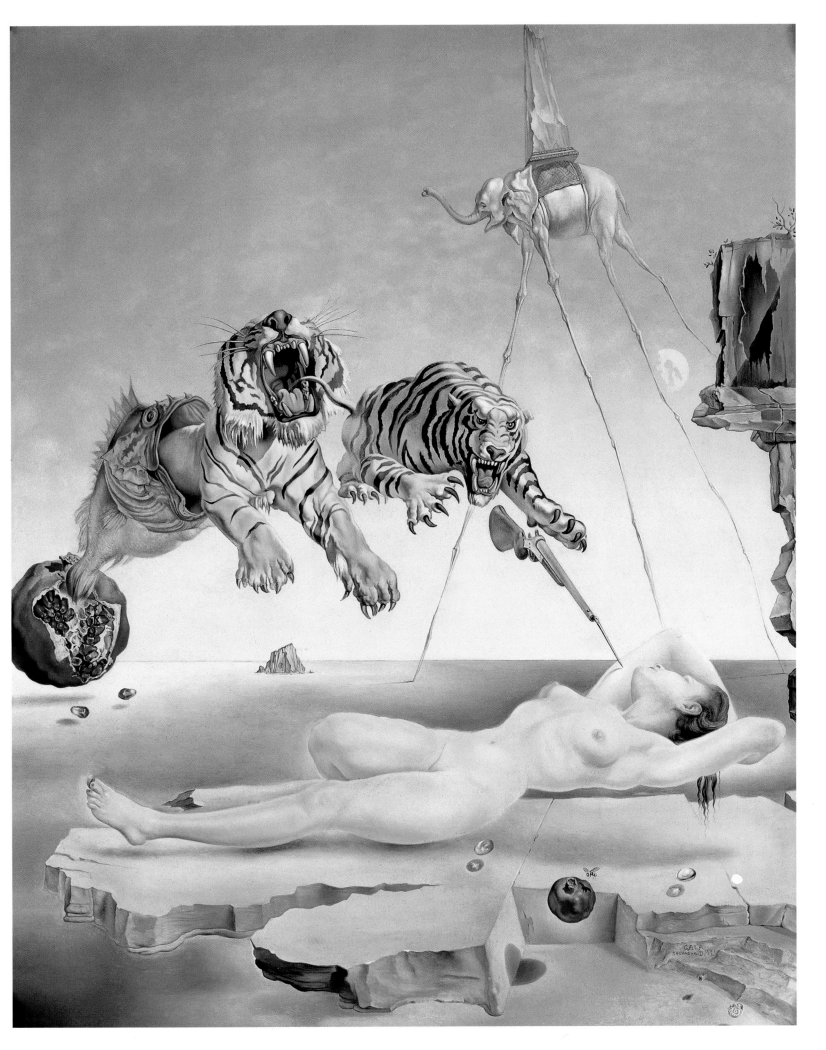

PAUL DELVAUX

Dawn Over the City

1940, oil on canvas, 175 x 215 cm
Private collection

b. 1897 in Antheit (Belgium),
d. 1994 in Furnes

Among the most important influences on Paul Delvaux's artistic development were the paintings of Giorgio de Chirico and the works of René Magritte. Delvaux first came across the two artists in the late 1920s, when he visited an exhibition that included works by Chirico and, shortly afterwards, made Magritte's acquaintance.

Like Magritte, Delvaux worked in seclusion. What linked Delvaux to the Surrealists was not the feeling – so important to many artists – of belonging to a group, but the fact that the painter also sought to create in his art an atmosphere evoking dreams and unreality. "Surrealism! What is Surrealism? In my opinion, it is above all a reawakening of the poetic idea in art, the reintroduction of the subject but in a very particular sense, that of the strange and illogical." This was the definition Delvaux offered during a 1966 lecture.

The strangeness of his paintings dates from the mid 1930s with the introduction of nude figures in a world in which the intimacy of nakedness is portrayed in a very public setting. In *Dawn over the City (L'aube sur la ville),* a central, male figure – a self-portrait of the artist – is surrounded by naked women slowly approaching him as if sleepwalking. They seem to represent a kind of existence impossible to reconcile with the normality of everyday life. As in Chirico's paintings the "classical" architecture, with its closely converging vanishing lines, is no more than lifeless decoration. It is part of a completely unreal space and provides a backdrop for encounters without sense or coherence.

"No one here thinks of eating, they are nourished by time, which passes and passes again; they drink the hours. Now I am in the presence of Claude Lorrain, but is not the heat, broken by sea breezes, too strong for this light?" These lines by the French author Michel Butor on *Dawn over the City* describe another important feature of Delvaux's painting – the inspiration of the Old Masters. Following the principles of collage devised by the Surrealists, Delvaux combines dream and painting. Thus he creates an imagined reality in which the protagonists, like the painter himself in *Dawn over the City,* seem like intruders set on causing trouble in the dream world.

However, Paul Delvaux's paintings not only reflect dreams, which he depicts using a seemingly naïve vocabulary. His art could also be termed mythological, since his paintings possess an encoded message only accessible to those who are familiar with the meaning of the place and its inhabitants, in other words, those who understand the language of the subconscious.

MAX ERNST

Approaching Puberty or The Pleiades

1921, collage of partly retouched photographs, gouache
and oil on paper, mounted on cardboard, 24.5 x 16.5 cm
Paris, Private collection

**b. 1891 in Brühl (near Cologne),
d. 1976 in Paris**

In 1921, the year in which *Approaching Puberty or The Pleiades (La puberté proche ou Les pléiades)* was created, Max Ernst was closely involved with the French Dadaists. His friendship with André Breton and Paul Eluard led to some joint projects and Ernst's active participation in the early stages of Surrealism.

Approaching Puberty or The Pleiades juxtaposes image and script. The detailed commentary underneath the picture harmonises with the image in terms of colour and composition. The text reads: "Approaching puberty has not yet removed the fragile grace of our Pleiades/ Our shadowy gaze is directed at the paving stone which is about to fall/ The gravitation of the waves does not yet exist." It determines our approach to a picture whose odd assortment of images defies spontaneous understanding.

In Max Ernst's "Biographical notes" the artist draws attention to the different levels of the work. We instinctively associate the grace of the Pleiades with the naked, headless, female figure cut out from a photograph and positioned in the centre of the picture. With certain trepidation we focus on the tumbling paving stone as it falls to the bottom of the picture, leaving a black trail behind it. Finally, gravitation can be linked to the blue background, which is in turn associated both with the female form hovering in mid-air and with the movement of the waves referred to in the text.

Of course, these connotations make no sense if we do not also take account of the meaning of the Pleiades in Greek mythology. Thus, the nude female figure can be seen to represent one of the seven daughters of Atlas, who was pursued by Orion. In order to protect them, Zeus turned them into a heavenly constellation. She might be Electra, who hid her face at the fall of Troy, which would explain why she appears headless in Max Ernst's collage. The word "Pleiades" may originally derive from "peleiades", meaning a flock of doves, so that the blurred outlines at the top of the collage could be interpreted as soaring birds.

This analysis of the contents of the collage leaves us with feelings of vagueness and the possibility of multiple meanings. There are various ways of understanding the work that may overlap or be mutually exclusive. Nor are interpretations based on reason likely to be satisfactory. We are looking at a universe ruled by the laws of dreams and the subconscious, a primitive world where neither gravity nor clear boundaries exist. Things of totally different consistencies stand side by side. Perhaps it is only now, as we view the composition so many years later, that we are able to witness the development of a new aesthetic, embracing suggestivity and the notions of decay and disintegration.

"A painter is lost when he finds himself."
Max Ernst

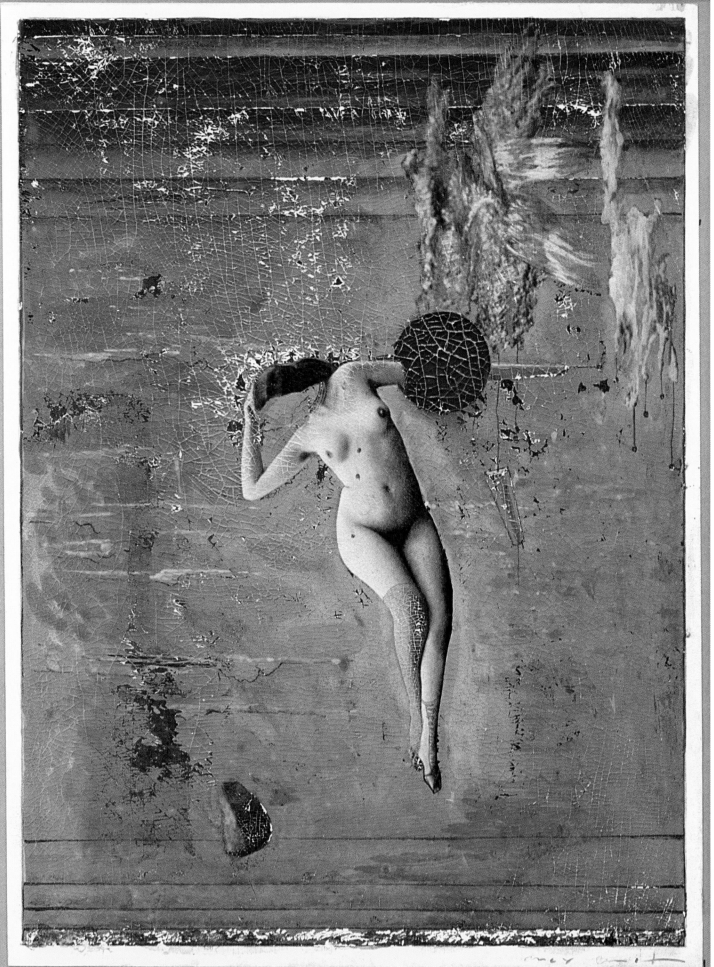

La puberté proche n'a pas encore enlevé la grâce tenue de nos pléiades/ Le regard de nos yeux pleins d'ombre est dirigé vers le pavé qui va tomber/ La gravitation des ondulations n'existe pas encore

The Elephant of Celebes

1921, oil on canvas, 125 x 108 cm
London, Tate Modern

In 1921 Paul Eluard bought *The Elephant of Celebes (Célèbes)* from Max Ernst, whom he had recently met and subsequently visited in Cologne. It was the first of several of his friend's works that Eluard was to purchase. In addition, Ernst painted murals for Eluard's house in Eaubonne.

The Elephant of Celebes, painted while Ernst was still in Cologne, applied the principle of paper collage to painting. The individual elements of this composition are not cuttings from different books, encyclopaedias or catalogues. Instead, Ernst translates the concept of collage, namely the bringing together of an assortment of incongruous and contradictory elements, into a *trompe l'œil* style of painting that simulates different materials. It is precisely the "realism" of the images that produces the "hallucinatory" effect the painter tried to achieve, an effect that Max Ernst associated with collage, as a passage in his autobiographic notes reveal: "One rainy day, in Cologne on the Rhine, my attention was attracted by the catalogue of an institution supplying teaching materials. I saw models of all sorts, mathematical, geometric, anthropological, zoological, botanical, anatomical, mineralogical, palaeontological and so on. Elements of such a different nature that the absurdity of collecting them confused the eye and the senses, provoking hallucinations and giving the objects represented new, rapidly changing meaning. I felt my visionary faculties suddenly so intensified that I seemed to see newly created objects in a new setting. In order to capture this it required only a little colour or a few lines, a horizon, a desert, a wooden floor and suchlike. So I obtained a fixed image of my hallucination." (1919)

In the case of the elephant of Celebes, the "new setting" is the first sign of another, different reality. The monstrous figure stands in a space that it takes us a few moments to realise is an underwater landscape. In what is supposedly the sky, two fish frolic against a background which, puzzlingly, is punched with holes through which cables protrude. But these are only minor causes of confusion. The beast with its round body and sturdy hosepipe-like protuberance looks like an elephant. It is, in fact, a machine based on a picture of a corn bin that Max Ernst came across in an anthropological journal. He adopted its simple, rounded shape and then added a trunk, which he adorned with a frilly cuff, a horned head and tusks.

The monster's name is taken from a line in a smutty schoolboy poem with sexual connotations, which Ernst remembered from his youth. In this context the Chirico-style tower on the right of the picture can be interpreted as a phallic symbol. There is also a possible mythological explanation for the presence of the graceful nude figure. Max Ernst could be alluding to the abduction of Europa by Zeus, father of the gods, disguised as a bull. The horned head at the end of the elephant's trunk could refer to the same myth.

At the First Clear Word, 1923

MAX ERNST

Loplop presents a flower or Anthropomorphic Figure with Shell Flower

1930, oil and collage on plywood, 99 x 81 cm
Geneva, Galerie Jan Krugier, Ditesheim & Cie

In his "Biographical notes", Max Ernst described Loplop, his alter ego, as a protagonist in the novel of the same name. The catalogue to a 1930 Max Ernst exhibition at the Galerie Vignon in Paris contained the words: "Loplop presents Loplop (private phantom related to Max Ernst, sometimes with wings, but always masculine)." This quotation is especially revealing – at least for spectators of the series of Loplop pictures created in the 1930s – for it confirms firstly Loplop's function as master of ceremonies and secondly his close connection with Max Ernst.

Loplop appears in the picture *Loplop presents a flower or Anthropomorphic Figure with Shell Flower (Loplop présente une fleur, ou Figure anthropomorphe et fleur coquillage)* as commentator and instructor, without the gestures and facial expressions that characterised history paintings of earlier eras. Instead, his body serves as an easel on which works are placed. Loplop, presenting a flower, is a typical representative of his genre. On top of the flat, right-angled body resting on a rostrum-like base, sits a small naïve-looking chicken's head, the only living creature in the painting. To some extent this provides a point of contact for the spectator, who is confronted with not one but several images. However, anyone hoping for an illuminating commentary will be disappointed. Loplop does not create a connection or suggest any unifying theme between the visual elements, each of which has been produced by a different technique.

Loplop, whose impudent face presides over the whole scene, wraps us in visual confusion. He ironically combines quotes from other pictures, artistic set pieces, allusions to reality and deceptive illusionism. Art presented in this way, like a blackboard on an easel, is not to be taken seriously, he seems to be saying. Pathos is out of place – a message that becomes particularly pithy when applied to another Loplop picture, *Loplop presents the Marseillaise*. Here, Loplop's head is replaced by the capital of a column, lending him a certain dignity, which does not prevent the spectator from seeing the painting he is presenting as completely ludicrous and ironic.

Loplop presents the picture in the usual way – as an easel on wide feet – and also pops up in the picture itself, appearing as an opulent female figure with a bird's head, sitting on a throne, gesticulating expansively, apparently singing or conducting "La Marseillaise". But this rendering of the French national anthem is not the only charade. Nothing in the picture is to be taken at face value. The composition itself is a sham. With the aid of frottage, Max Ernst creates a picture comprised of structures so dramatically different from each other that they undermine the whole concept of classic artistic unity.

Loplop, 1932

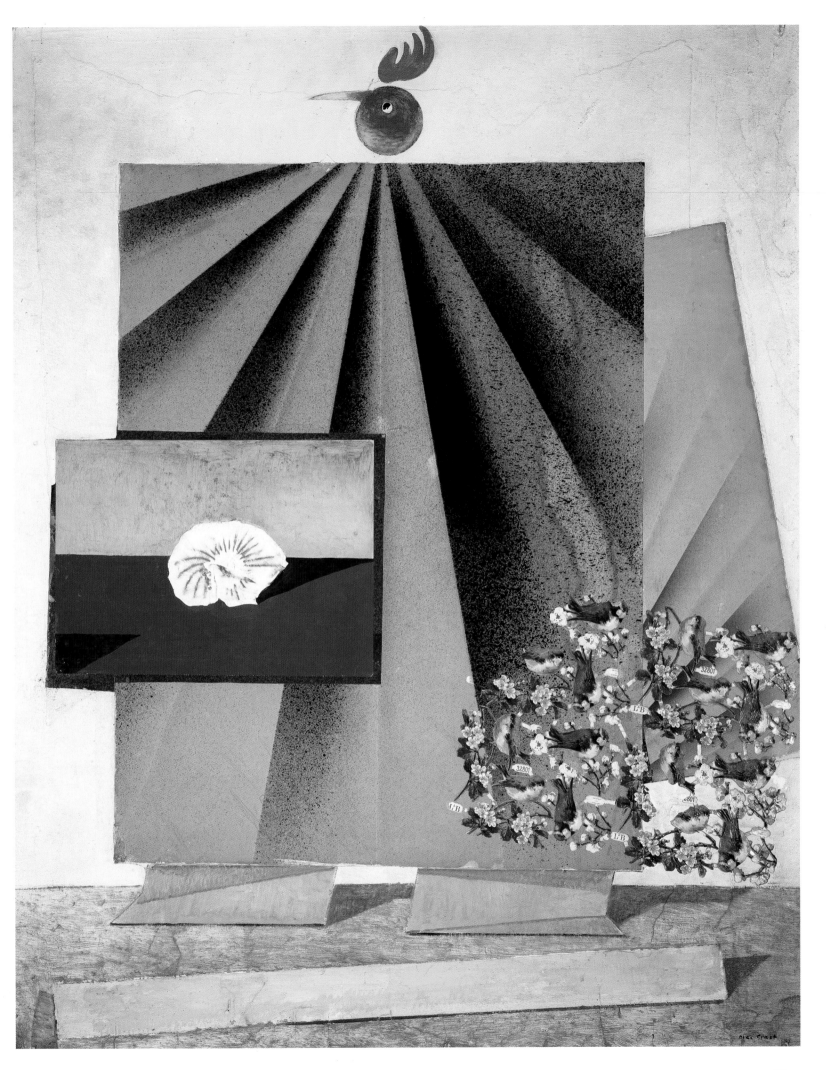

MAX ERNST

The King Playing with the Queen

1944, plaster (original version), 97.8 x 46.4 x 52.3 cm
Riehen/Basle, Fondation Beyeler

Max Ernst and Dorothea Tanning spent the summer of 1944 as guests of the gallery owner Julien Levy on Long Island. There, Ernst embarked on a thorough investigation into the intricacies of chess. Having modelled chess pieces and turned them into sculptures in 1929, he once again used chessmen as the basis for works whose meaning and effect went far beyond the technical problems of the game. Unlike Marcel Duchamp, who in 1923 started playing chess impassionately and by 1932 was even writing about chess problems for a specialist magazine, Max Ernst was more concerned with the game's magical and literary qualities. The world opened up to the spectator by his chess pieces could be compared to the kingdom created by Lewis Carroll, a favourite author of Ernst's. In "Through the Looking-Glass", Carroll leads his young heroine Alice into a different reality, a world inhabited by chess pieces on the other side of the mirror.

The scene set by Max Ernst is played out on a flat surface over which looms the half-length figure of the king. The king is both a chess piece and a player. His two long arms seem to move, preparing to shift the other pieces. His right arm shields the relatively large queen, while the remaining, smaller pieces are lined up on his left. It is obvious from the position of his left hand, which looks as though it might be about to produce a pawn from up his sleeve, that he is less interested in the other pieces than he is in protecting the queen.

The special relationship between king and queen is clear from the title of the sculpture – *The King Playing with the Queen (Le Roi jouant avec la Reine).* As well as romantic, fairy-tale associations, this also has erotic connotations, intensified by the horns on the head of the king who possessively and protectively surrounds the queen. He reminds us of the sensual and violent Minotaur that terrorises beautiful naked women in the works of Picasso, although Max Ernst's sculpture is characterised by strong, abstract forms. Observing the king's demonic appearance, his authoritarian manner towards the smaller pieces and the line of his arm as it encircles the queen, we think of an omnipotent ruler, a despot or prehistoric deity directing and manipulating the drama being played out on the world stage.

The King Playing with the Queen could be interpreted as an image of the power struggle taking place in the great arena of history, the tragic armed conflict that was at its height in 1944, the year in which the work was created. The war also cast its shadow over Ernst's own life as he was forced to escape from France and into exile in America. But his sculpture seems to possess even more layers of meaning. In the context of the artist's Surrealist connections, *The King Playing with the Queen* can be read as a symbolic representation of "the other side" of each of our lives. It can be seen as the image of a superior force whose hidden manipulations control and decide our action without our realising it.

Capricorn, 1948/1964

ALBERTO GIACOMETTI
Man and Woman

1928/29, bronze, 40 x 40 x 16.5 cm
Paris, Musée National d'Art Moderne, Centre Pompidou

b. 1901 in Borgonovo (Switzerland),
d. in 1966 Chur

In 1922 Alberto Giacometti moved from Geneva, where he had studied for a year at the city's École des Arts et Metiers, to Paris, where he was a pupil of the French sculptor Antoine Bourdelle. His work was shown in public for the first time when he took part in an exhibition at the Salon des Tuileries in 1925. In 1930, Giacometti met the Surrealists Louis Aragon, André Breton and Salvador Dalí. The photographer Brassaï visited Giacometti's Paris studio around this time, describing it as a "plaster grotto", filled with sculptures, which he compared to "stalactites and stalagmites". Brassaï saw them as objects that would become part of dreamlike configurations, as symbols of unconscious feelings and suppressed desires.

Brassaï's point of view captures the essence of Giacometti's sculptures dating from that particular creative period. *Man and Woman (Homme et Femme)* seems to use the language of forms to reduce the relationship between man and woman to physical desire, which according to Freud is the motivating force behind all human behaviour. Giacometti develops his sculpture from two elements. These are clearly identifiable as male and female, in the sense that the two are presented as the personification of their respective sexual organs.

The male part of the sculpture is reminiscent of a bow and arrow, while the female element is shaped like a goblet ready to receive the spike pointing towards it. With *Man and Woman,* Giacometti sculpted a highly abstract and austere piece of symbolism, which the spectator can instinctively understand and inter-

pret in different ways. On the one hand it is a very dynamic composition, in which the soft vitality of the female figure and the zigzag lines of her upper body respond to the tension of the bow which provides the propulsive force that drives the masculine arrow. On the other, the figures representing man and woman also form a static, immovable structure which seems to confirm that fate has bound them together for all eternity.

This bond finds violent expression in *Woman with her Throat Cut (Femme égorgée).* Like a giant insect, the woman lies dead on the ground. The inordinately long, thin arms and legs are spider-like, the large vertebra and ribcage are reminiscent of a beetle's shell and the small head could belong to a worm. Only the breasts curving above a narrow waist belong to a human body. In creating this complex structure in which the victim appears as the aggressor, could Giacometti be playing with the biological phenomenon that the Surrealists elevated to mythical status – the female praying mantis that eats the male after mating?

Woman with her Throat Cut, 1932–1940

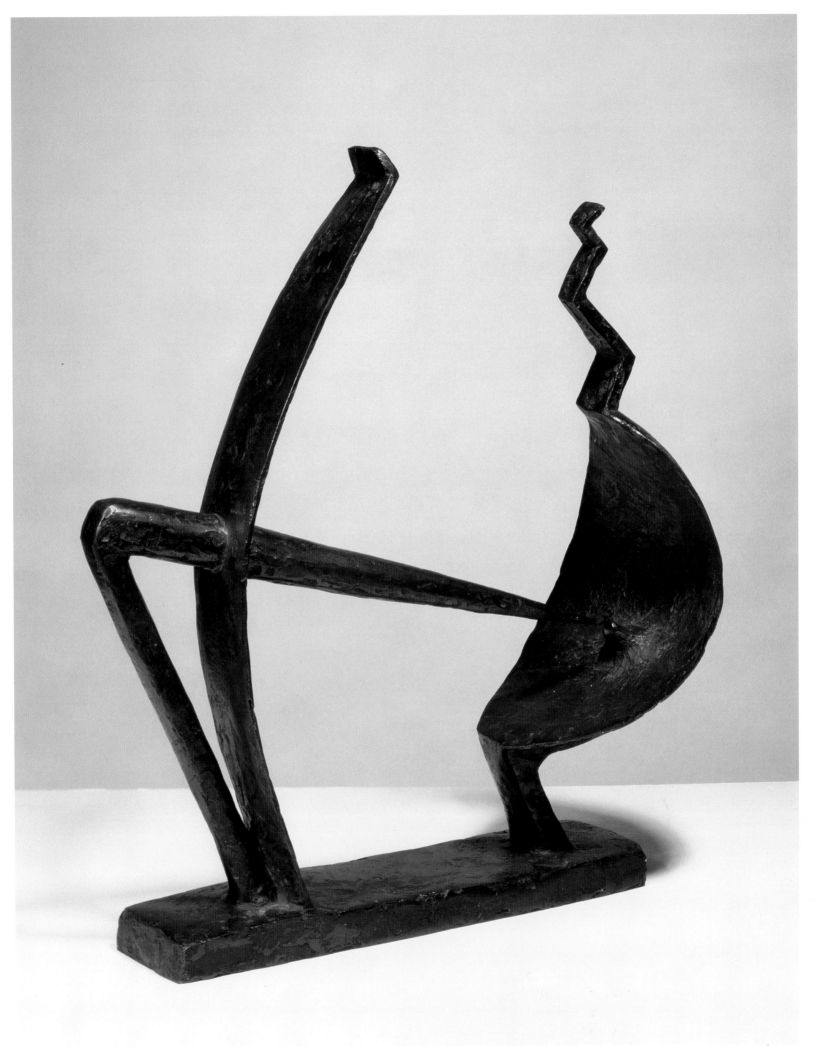

Room Perspective with Inhabitants, 1921, 24

1921, watercolour over oil transfer drawing on French Ingres paper mounted on cardboard, 48.5 x 31.7 cm
Berne, Kunstmuseum Bern, Paul-Klee-Stiftung

b. 1879 in Münchenbuchsee (near Berne),
d. 1940 in Muralto (near Locarno)

In the "First Surrealist Manifesto" of 1924, André Breton lists a number of poets and writers who, in his view, were sympathetic to Surrealism. Only once does he mention visual artists present and past, among them Paul Klee. In fact, in 1925, Klee exhibited alongside the Surrealists, Hans Arp, Pablo Picasso, Man Ray and Pierre Roy at the Galerie Pierre in Paris. Klee did not select any of his current works for the show, turning instead to two watercolours painted in 1920 as a response to seeing works by Chirico. The first of these, *Room Perspective with Inhabitants (Zimmerperspective mit Einwohnern, 1921, 24)*, was pictured in the exhibition catalogue and significantly renamed *Chambre spirite*. The new title was not only more in tune with the Surrealist world of the imagination than Klee's laconic title; *Chambre spirite (Spirit room)* accords perfectly with the shadowy and dramatically foreshortened perspective of a space in whose vanishing lines several figures are helplessly entwined. The introduction to the catalogue, written by André Breton and Robert Desnos, suggested a quite different approach to the work, more poetic and rich in associations. They saw the unsettling tunnel-like image as an opening in a mountain: "Très loin un homme s'apprête à gravir la montagne entr'ouverte" (In the far distance a man prepares to climb the half-open mountain). It is difficult to gauge now how far Klee agreed with such an interpretation. Even so, at that time he was striving to make artistic connections with ideas other than the Constructivist and Functionalist tendencies that predominated at the Bauhaus in Dessau, where he was a teacher. Klee sought to give his art a broader framework and to liberate the spectator from a banal reality that was no more than a surface beneath which other worlds lay hidden. His objective of revealing the "true" ideas behind visible things – a deeply Romantic way of thinking – brought him very close to the Surrealist position.

In a whole series of prints dating from the early 1920s in which Klee played with variations on the theme of perspective, we the spectators are admitted to some bewildering spaces. We look, as though through a tunnel entrance, into a room that extends endlessly into the distance with walls, ceilings and floors covered with vanishing lines. People, pieces of furniture and objects are caught up, as if in a spider's web, in this structure, which began life as a framework to guide the artist but has now turned into a net – or prison bars. In 1919 Max Ernst had visited Klee in Munich and introduced him to works by Chirico published in the periodical "Valori Plastici". These must certainly have been an important source of inspiration for Klee's experiments with perspective.

"Things appear in an extended and multiplied sense, often seemingly contradicting the rational experience of yesterday."
Paul Klee

1921/24 Zimmerperspective mit Einwohnern †

WIFREDO LAM

The Jungle

1943, gouache on paper on canvas, 239.4 x 229.9 cm
New York, The Museum of Modern Art, Inter-American Fund. 1

b. 1902 in Sagua la Grande (Cuba),
d. 1982 in Paris

Wifredo Lam's mature work, created in the 1940s, reflects both the painter's roots in the culture of his native Cuba and his relationship with artists of the European avant-garde. It was under their influence that he rediscovered, and mirrored in his art, the primitivism he had known during a childhood spent in close contact with the natural world.

After training at the Escuela de Bellas Artes in Havana, in 1923 Lam began attending free painting classes in Madrid and continued his artistic education by studying the Old Masters in the Prado. But it was the four years spent in Paris, from 1938 to 1941, that were to be the most decisive for Lam's development as a painter. There, he formed a close relationship with Pablo Picasso, and together they exhibited their work at the Perls Galleries, New York in 1939.

Of course, while he was in Paris, Lam also came under the influence of the Surrealists, whose interest in the supernatural, the irrational and magic was fertile soil for the Cuban painter. "When I was small, I was frightened of the power of my own imagination. At the end of the town of Sagua la Grande, near our house ... the forest began ... I never saw any ghosts but I invented them. When I went for walks at night I was scared of the moon, the eye of the shadows. I felt I was an outsider, different from the rest. I don't know where it comes from. I have been like that since childhood."

The forest of his childhood crops up again in Lam's jungle pictures, which date from the early 1940s, before he fled Fascism and returned to his homeland. In his greatest composition, *The Jungle* (1943), now in New York's Museum of Modern Art, he intersperses monstrous beings, close relatives of Picasso's surreal creatures of the period, among the Cuban sugar cane. Unlike Picasso, Lam does not create monumental versions of these creatures inspired by African sculpture and primitive art. Instead he stresses their diversity and their omnipresence amid the dense vegetation, through which their constantly murmuring voices seem to penetrate.

"When I painted it (*The Jungle*), the doors and windows of my studio were open so that passers-by could see in. They cried: 'Don't look, it's the Devil!' And they were right. One of my friends correctly found in the picture a spirit close to that of some representations of Hell done in the Middle Ages. In any case, the title does not correspond with the reality of nature in Cuba, where one does not find jungle, but *bosque, monte, manigua* – woods, mountains, open country – and the background of the composition is a sugar-cane plantation. My painting had to communicate a psychological condition."

Both creatures and plants in the jungle display the same metallic materiality. They are bathed in a subdued light that makes them seem like figures in a fantasy, a fantasy that has much in common with the Surrealists' interest in sexuality and violence. Lam's stylization of plant and organic forms is a long way from the old-masterly illusionism of Salvador Dalí, and it doesn't bear much relationship to Max Ernst's forest pictures. On the contrary, it is much closer to the painting of Matta. Despite all the figurative elements in their work, both Lam and Matta appear, in their rhythmic repetition of non-representational forms, to point the way towards Abstract Expressionism.

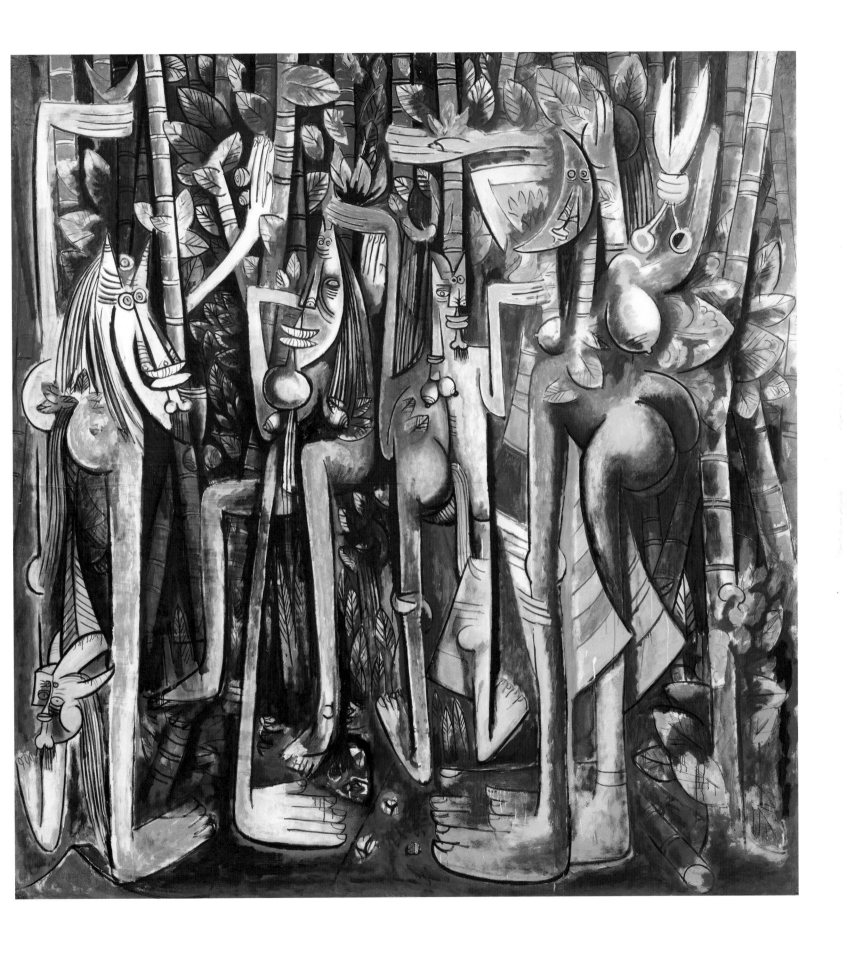

RENÉ MAGRITTE

The Key to Dreams

1927, oil on canvas, 38 x 53 cm
Munich, Pinakothek der Moderne

**b. 1898 in Lessines (Belgium),
d. 1967 in Brussels**

The series entitled *The Key to Dreams (La clef des songes),* which plays such a special and central role in René Magritte's work, was painted between 1927 and 1930. Magritte's "word-pictures" tackle the notions that characterise his landscapes – mystery, the unsayable and the unnameable – on many different intellectual levels. At first, however, they seem simplistic and banal.

The Key to Dreams is a composition divided into four equal sections and seen as if through a painted-on window frame. In each of the quarters, which look like small blackboards, Magritte has painted highly realistic objects, labelled underneath in a schoolboyish hand. Only one – "L'éponge" (sponge) – has the correct caption. The three other objects are wrongly labelled. A handbag is entitled "Le ciel" (The sky), an open pocket knife is "L'oiseau" (The bird) and a leaf is identified as "La table" (The table). To the spectator standing in front of the picture, which calls up associations of carefully formed handwriting on a school blackboard, or the accurate illustrations in an encyclopaedia, the incorrect labelling would at first seem to be a mistake, were it not for the correctly named sponge, where name and image correspond. Because this system of classification is not totally incorrect, we instinctively look for a different way of ordering things. The fracture in the system, the thin crack in what we see as normal and customary, provokes the thought process the painter intended.

During his time in Paris, Magritte was already becoming interested in the relationship between word, image and object as a theme in the visual arts. His concern was reflected in the many variants of the word-picture he produced at that period. As for the theory, Magritte's first contribution to the journal "La Révolution surréaliste", in the same edition that carried the "Second Surrealist Manifesto", reported on the results of his explorations. He outlined eighteen rules, each illustrated by a sketch, governing the relationship between word and image. These highlight the difference between the written and spoken word and visual language, which, as Magritte wrote in a letter to Camille Goemans, is a condition of the mind. When we examine the differences between words and objects and between mind, body and ideas, they become even greater.

Magritte's eighteen rules show that, in reality, an object's image (i.e. the one assigned to it by convention) and its name (i.e. the one assigned to it by another convention) have different functions. In view of those differences – which at the same time imply independence and equality – a word or an image can take the place of a real object or can designate an object. This occurs through the conscious evocation of a "mental image". Words and images may, however, designate nothing but themselves. Their meaning only becomes clear when they are used and mixed together.

"One object suggests that there is another lurking behind it."
René Magritte

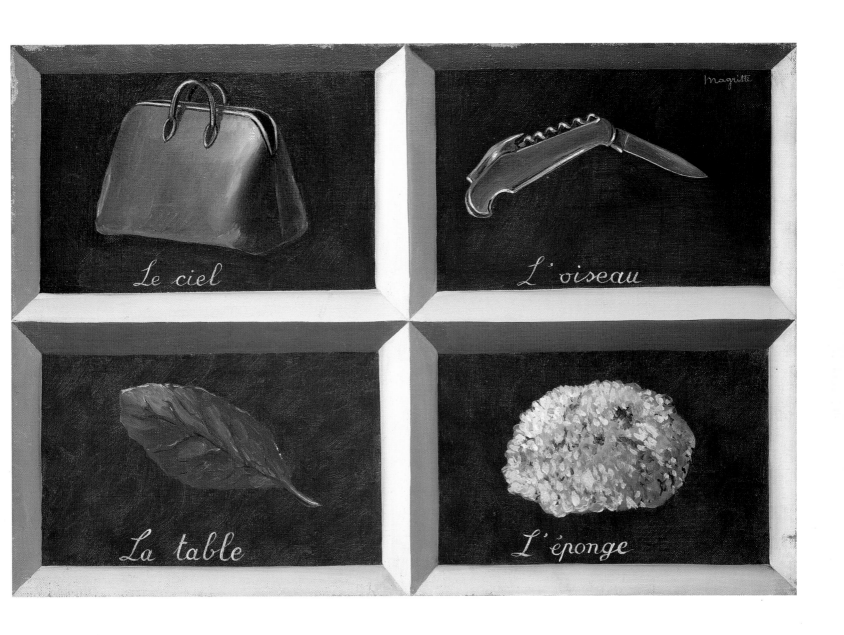

The Door to Freedom

1933, oil on canvas, 80 x 60 cm
Madrid, Museo Thyssen-Bornemisza

After studying at the Académie Royale des Beaux-Arts in Brussels and working briefly as a commercial artist, René Magritte, impressed by the paintings of Giorgio de Chirico, painted his own first Surrealist picture in 1925. In Paris, Magritte joined the group of Surrealists led by André Breton and from 1927 to 1930 made his home at Perreux-sur-Marne close to the French capital. However, after this relatively short stay, he returned to Brussels where he remained until his death, living a quiet, unspectacular and outwardly normal middle-class life.

The life of the painter, whose public demeanour diverted attention from a real existence devoted entirely to his art, is mirrored in his paintings of seemingly ordinary subjects whose real intention is to point to something hidden, to provoke feelings of insecurity and create an air of mystery. Magritte's landscapes, which constitute a major part of his output, set out to explore these issues, although at first they appear much easier to understand than traditional landscape paintings. The "realistic", eye-catching style of Magritte's painting, his simple clear compositions and his concentration on essentials, are like plain language without any deeper meaning. Only close analysis reveals the ambiguity of his works.

The Door to Freedom (La clef des champs) is a particularly striking example of the hidden presence of something mysterious. Through a window we see a gentle, hilly landscape. At the end of a broad meadow extending uphill stand several leafy trees, above them a dome of delicate blue sky. This would be a perfectly cheerful image, if it were not clearly breaking up before our eyes. As we look though the window pane, it shatters into a thousand fragments. Pieces of broken glass remain in place like transparent film in front of the vista. The shards that have fallen to the floor are like pieces of a jigsaw reproducing the scene observed through the window.

Was the landscape only painted on the window pane? Is this not a transparent pane at all, but a painting? No clear expla-

nation is possible and so we conclude that the pieces of glass on the painting are a contradiction. The landscape beyond the broken window is still unscathed and visible. At the same time, the broken glass that has fallen to the floor is not transparent but shows pieces cut out from the landscape, while we can still see through the glass that remains stuck in the window frame. We as spectators feel called upon to carry out a visual reconstruction but, try as we may, we cannot achieve any complete certainty.

The relationship between reality and painting is permanently destroyed; despite Magritte's talent for creating an illusion, we can no longer sustain any real belief in either image or reflection. The certainty guaranteed by paintings of centuries past, recalled by the *trompe-l'œil* curtain drawn to the sides of the window, is no longer there.

"My painting is visible images which conceal nothing; they evoke mystery. ... Mystery means nothing either, it is unknowable."
René Magritte

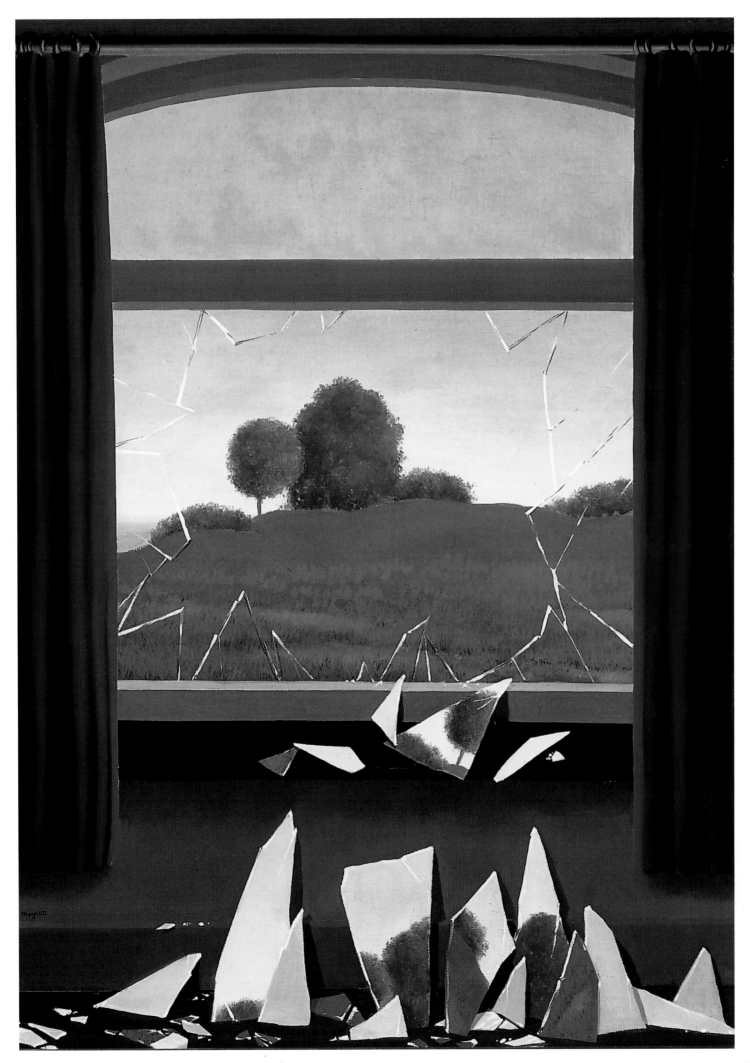

Time Transfixed

1938, oil on canvas, 147 x 99 cm
Chicago, The Art Institute of Chicago,
Joseph Winterbotham Collection

In the painting *Time Transfixed (La durée poignardée)* René Magritte seems to capture all the feelings associated with time standing still. Every detail of his museum-like setting reflects the slow passage of the minutes shown on the clock on the mantelpiece. Nothing ever seems to happen, nor, one suspects, will anything ever happen in this room, a section of which Magritte reproduces in meticulous detail. Only the monotonous ticking of the clock between the two candlesticks breaks the silence, adding even more to the boredom. What are we waiting for? What has happened here? What is going to happen?

In this atmosphere fraught with tension, the locomotive penetrating the fireplace, absurd as it may seem, comes almost as a relief. Only an event on this scale, unstoppable and ear-splitting, could shatter the forbidding silence of this strange, hostile space. Moreover, we have the odd impression that this undersized engine with its smoke billowing up the chimney actually belongs with the room. Drawn with draughtsman-like precision, it shares a certain kinship with the other objects and structures in the room – the black clock, the classical fireplace, the simple frame of the mirror and the uncomplicated candlesticks. All of which makes the scene even more puzzling.

In an essay written in 1928 and entitled "Theatre in the Midst of Life", Magritte portrayed his art as a stage on which the natural laws of time and space cease to apply. Scenes are played out in which a princess strides through a wall, pieces of fruit on a table represent birds, there are unexplained shadows and open doors with nothing behind them.

A similarly surreal atmosphere pervades Magritte's 1928 painting *The Voice of Silence (La voix du silence)*. It is a picture of two halves. On the right, we see a cosy middle-class living room with a sofa, a picture on the wall, shelves and house plants. The left side of the picture, however, is plunged into impenetrable darkness, opening up a way into the void. We are given a glimpse into the murky world of imaginary dangers and fears, as vague feelings of menace and entrapment increase. Suddenly the familiar room on the right seems no more than a façade behind which lurk unknown horrors, a mask behind which we hide in dread.

How is it possible to live with this sense of bewilderment that Magritte chose as the theme of his art? How can we deal with the sudden disorientation that can shatter the most banal existence? As Magritte understood it, the artist first and foremost directs his consciousness to life, not to ideas, like the philosopher, or to art, like those artists content merely to achieve success in the art world. To the Surrealist painter, nothing apart from life itself can be an end in itself. Art (a vehicle for ideas) is a by-product of life, and works of art do not impinge on real life.

The Voice of Silence, 1928

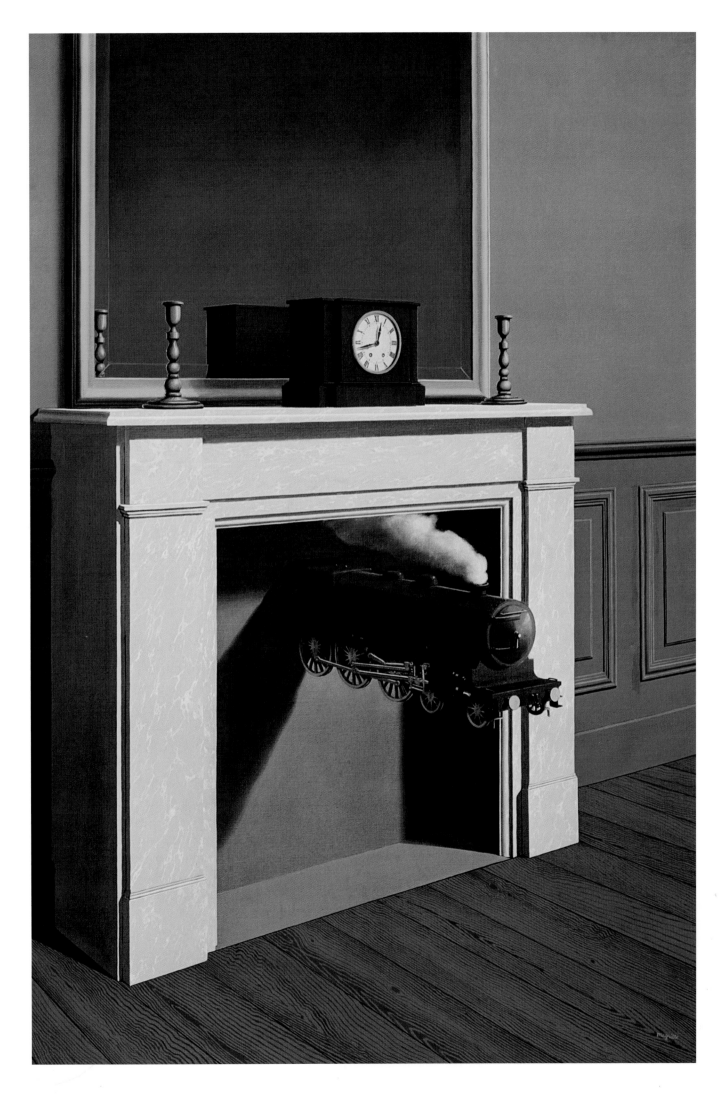

RENÉ MAGRITTE

The Empire of Lights

1954, oil on canvas, 146 x 114 cm
Brussels, Musées royaux des Beaux-Arts de Belgique

"The void is the only great wonder of the world."

René Magritte

Empire of lights (L'empire des lumières), a theme that René Magritte revisited several times in the 1950s, shows a peaceful scene. A house with a street lamp outside stands in a quiet square in front of a tall tree. The shutters are closed, apart from those at two upstairs windows, where the lights are on. Everything is silent. The dark trees surrounding the house seem to watch over it as it sleeps. Only slowly do we grasp the fact that there is a fracture running through the entire composition. Above house and trees we see a bright, daytime sky, scattered with fleecy white clouds. It is part of the picture but nevertheless alien and other-worldly, since the light from the sky has no effect on the scene in the foreground. Day and night collide but do not connect. They are part of the same world and yet are estranged. They are as different from one another as the states of wakefulness and sleep.

Magritte was fascinated by this association of opposites. As he explained in an essay on *Empire of Lights*, the idea behind a particular painting is not visible in the painting, in the same way an idea is not visible to the eye. The eye can see what the picture represents, but what it represents are the things that result from the process of thinking. *Empire of Lights* also represents these things or, to be more precise, it shows a nocturnal landscape and a daytime sky. The landscape recalls night, the sky, day. Magritte writes that the evocation of night and day appears to have the power to surprise and delight us. His name for this power is poetry and the reason he believes in its existence is because he has always been interested in night and day, without preferring one to the other. Both fill him with astonishment and wonder. This insoluble puzzle not only fascinated Magritte. It was also at the very centre of Surrealist thought.

André Breton, who also wrote about *Empire of Lights* in 1964, characteristically emphasised the close and confusing relationship between light and shadow in Magritte's painting. The work, he said, defied generally accepted ideas and conventions to such a degree that anyone passing quickly by the painting might imagine seeing stars in the daytime sky. Since the publication of Breton's "First Surrealist Manifesto", the Surrealists had proposed new ways of seeing as an alternative to "generally accepted ideas and conventions". Their ideas were much more relevant to the realm of creativity than actions guided by reason. The language and imagery of dreams were crucial factors in the creation of Surrealist art, and individual artists each had quite different ways of exploiting these rich sources of inspiration.

The Empire of Lights, 1953

68

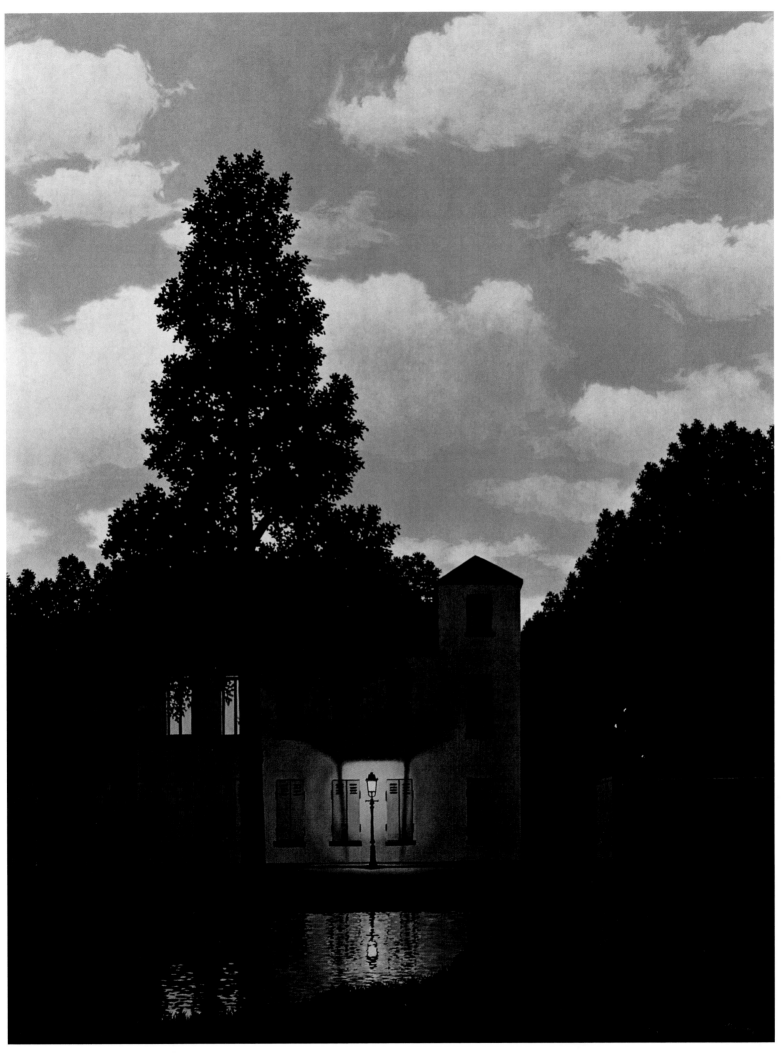

ANDRÉ MASSON

The Villagers

1927, oil and sand on canvas, 80.5 x 64.5 cm
Paris, Musée National d'Art Moderne, Centre Pompidou

**"The painter's hand … flies free …
it is … in love with its own movement
and in nothing else, and now delineates
the forms which arbitrarily appear."**

André Breton

b. 1896 in Balagny-sur-Thérain,
d. 1987 in Paris

The group of friends who in the early 1920s used to meet regularly at André Masson's studio on the rue Blomet in Paris – among them Antonin Artaud, Robert Desnos and Michel Leiris – appreciated Masson's clear awareness of human ambiguity. But what relevance does this have to Masson's art? If we take ambiguity to mean a lack of coherence between human thought and action, perception and behaviour, and apply these disconnected and unrelated concepts to a painting, it implies that the work can be interpreted on two levels. On the one hand the special textural qualities of Masson's paintings convey emotions, moods and a particular atmosphere. On the other, we have a linear drawing which appears abstract but which also contains recognisable figures and objects. It seems as if these figurative elements have been created without the conscious control of the artist, in line with André Breton's definition of *dessin automatique* – an automatic method of drawing capable of producing seismographic images without any rational control by the artist.

André Masson's drawings bearing the title *Automatic drawing (Dessin automatique)* consist of interwoven lines, which at first sight look like a net created quite fortuitously. Only on closer examination do we perceive nameable forms, as in the work seen here, dating from 1925/26. In this case, we can make out limbs, feet, hands and, here and there, eyes, faces and genitalia. The uncontrolled, spontaneous creative process gives the impression of a composition that changes under the eyes of the spectator, opening up a whole series of new and different perceptions.

At least as influential as Surrealism on Masson's work were his own earlier education and his interest in Nietzsche's philosophy, classical literature and mythology. His passion for these subjects led to his great themes – wars, massacres and heroism. His compositions always deal with figures who, unaware of the fate awaiting them, defenceless against the tides of life and relying on their instincts, are simply swept away. This is true of the villagers in the picture *The Villagers (Les Villageois)*. A line drawn in the sandy ground demarcates the whole world in which they live. The line leading from the eye of the crude figure in the centre also embraces elements arbitrarily chosen from his surroundings: a cockerel, a bird's head, a broad foot that casts a tangible, red shadow suggesting death and violence. The earthy colours and the texture of the sand also symbolise village life. The villagers are part of the natural world that has shaped them, the environment from which the artist has created an image of their lives, even going so far as to scatter sand on the canvas.

Automatic drawing, 1925/26

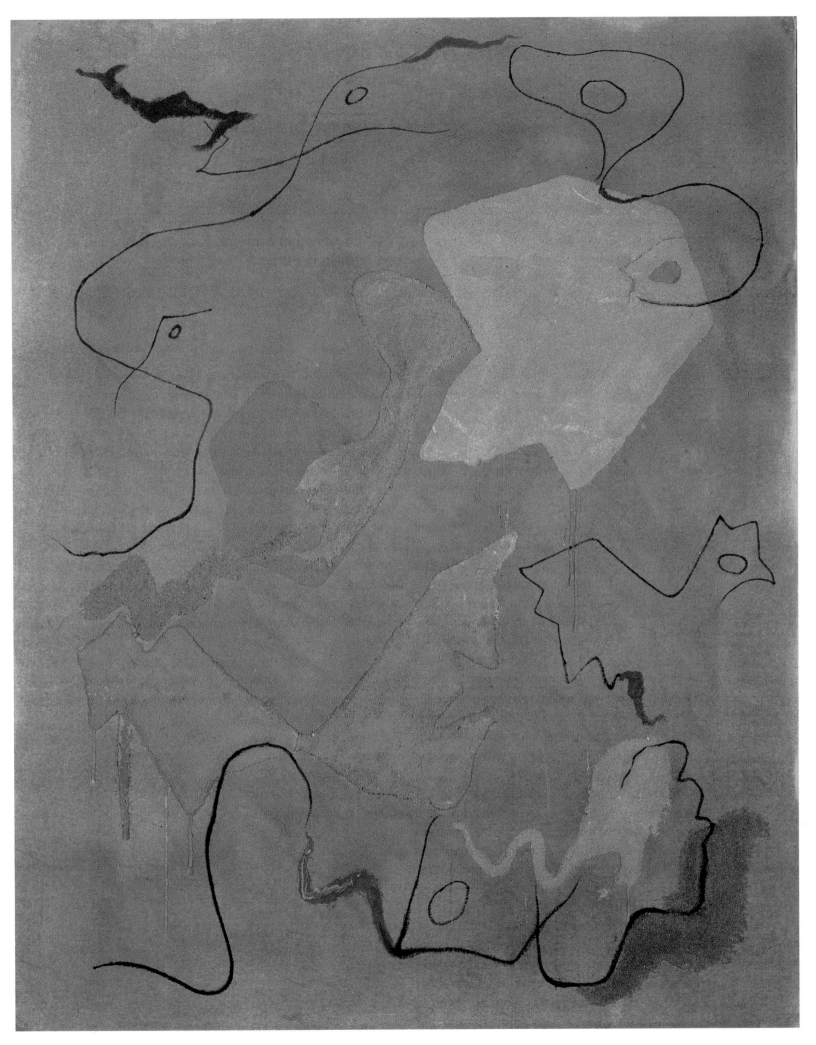

MATTA

Year 44

1942, oil on canvas, 97 x 127 cm
Berlin, Neue Nationalgalerie

"Painting always has one foot in architecture, one foot in dreams."
Matta

b. 1911 in Santiago de Chile,
d. 2002 in Civitavecchia

It was in 1937, relatively late in the history of the Paris Surrealists, that Matta (Roberto Sebastián Antonio Matta Echaurren) met André Breton and his circle. Matta had worked in Le Corbusier's studio in the city. "I met them and I was so ignorant that they were not interested in me. But then they looked at my drawings and said 'You are a Surrealist'." In an interview, Matta described his first encounter with a group of artists who would permanently influence his development as a painter. Their support would also help him deal with intellectual problems resulting from his unsatisfactory attempts at architecture. "The question was 'how can we find out more about what a house should actually be, who it should be built for?' In short, who is the guy I am building it for? ... Instead of designing houses I designed a state of being – you could call it psychology. I wanted to grasp how the human mind worked. That's why I began to paint without being a painter. I had never been to art school. But how could I represent psychological function? I called the first paintings *morphologie psychologique* – psychological morphology – morphology of desire, morphology of fear, morphology of pain ... We simply do not have the language to express these things ..."

Matta's paintings present people in space. His figures, seemingly deprived of their outer covering, with their nerves and emotions laid bare, appear in a space that affords them no refuge or protection and bears absolutely no relation to what we would term a house, room or building. In an 1946 article for "Société Anonyme", Marcel Duchamp wrote that Matta's most important contribution to Surrealist painting was his discovery of spaces that art had so far left unexplored. Matta, said Duchamp, followed modern physicists in their search for this new space which, although represented on canvas, could not be mistaken for yet another three-dimensional illusion.

Year 44 (L'année 44), painted in 1942, does not depict space but merely lets the spectator experience it. It conveys the feeling of a person enclosed in a space that echoes his emotions. Matta combines different painterly effects to create that impression – bright draughtsman-like structures on an iridescent red and black background. Floating particles of colour alternate with precisely drawn details, vaguely anatomical fragments seem to interact with the surrounding space, letting it dictate their movements.

Matta's concrete drawings also convey a similar feeling of powerlessness. In *Offences (Les délits),* amid sketches experimenting with movement, dynamics or form, we see couples enacting a series of scenes as in a comic strip. They are involved in sexual, sadistic, even pornographic situations in which they appear to be willing participants rather than victims.

Offences, c. 1942

JOAN MIRÓ

Stars in the
Sexual Organs of Snails

1925, oil on canvas, 129.5 x 97 cm
Düsseldorf, Kunstsammlung Nordrhein-Westfalen

b. 1893 in Montroig (near Barcelona),
d. 1983 in Palma de Mallorca

From 1924 onwards, Joan Miró played an active role in the Surrealists' exhibitions and manifestations. This period also marked a turning point in his work. After an initial phase heavily influenced by Cubism and several paintings that could well be described as "magic realism" Joan Miró turned to a style of painting that would truly express what he called the "sparks of the soul". Enthusiastically, he flung himself into paintings in which monstrous or angelic animals, trees with ears and eyes, and even the odd Catalonian peasant with the cap and rifle typical of the region, stand side by side, but without any apparent connection between them. The element that binds them is an atmosphere far beyond any normal perception of reality. Miró's paintings dating from that era might be termed "visions", namely works that open up a space in which dream, poetry and painting meet. In them, concrete forms melt into cloudy areas of colour over which hover magical signs that mingle with lines of poetry to create a dreamlike image.

Stars in the Sexual Organs of Snails (Etoiles en des sexes d'escargots) is not only a title added to a painting, the lines of script are also an integral part of the composition. The phrase is written in three lines over spirals of soft, blue paint whose shape and colour carry vague associations with snail shells. The letter "t" of the word "escargot" – snail – is caught up in the large red circle in the upper centre of the painting. The soft rounded shape is penetrated by a shooting star, while its lower section is crossed by a black line that links together several of the soft, blurred forms in the bottom half of the painting. The peculiar content and the irregular lettering recall the process of *écriture automatique.* The painting alternates between hard and soft, precision and fluidity, evoking the indefinable sensation of dreaming with its vague awareness that strange, irrational things are happening.

Meanwhile, *Photo – This is the Colour of my Dreams (Photo – Ceci est la couleur de mes rêves),* painted in the same year, explores the divergence between rationality and dreams in a quite different way. This is, once again, a "picture poem" in which the writing is an essential ingredient. Conscientiously, like a little boy in his first year at primary school, Miró has written the black letters on the pale canvas: top left in large letters, "Photo", bottom right "ceci est la couleur de mes rêves". The phrase is illustrated by a hazy blue cloud, setting off a seemingly endless series of questions. Do dreams have colours? Can they be photographed? What is hidden behind the blue cloud? Or are the strange remarks written under the inkblot just a bored schoolboy's joke?

Photo – This is the Colour of my Dreams, 1925

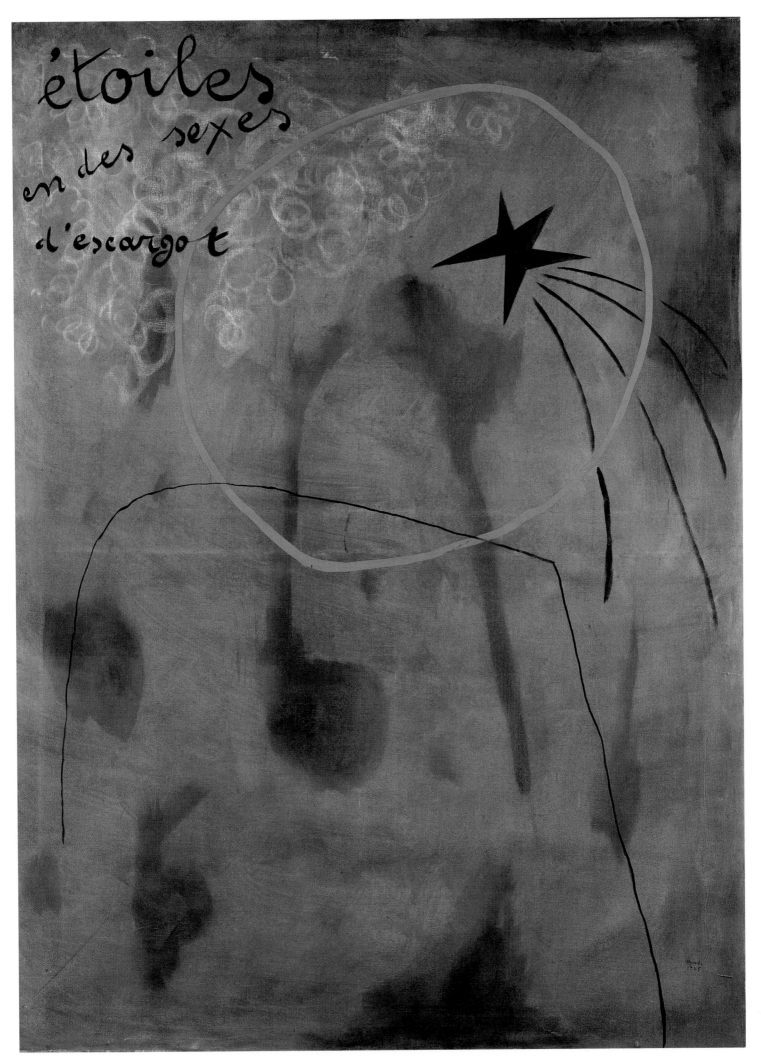

JOAN MIRÓ

Collage

1928, charcoal on paper, roofing felt,
wallpaper, 99 x 69.5 cm
*Munich, Pinakothek der Moderne,
Sammlung Anette und Udo Brandhorst*

**"More important than a work of art itself
is its effect. Art can pass away, a picture can
be destroyed. What counts, is the seed."**
Joan Miró

From 1926 onwards, Joan Miró's artistic activities extended beyond painting. He designed stage sets and made objects combining the most incongruous elements and materials. He then went on to create a series of collages, of which this has to be one of the most impressive examples. While in his paintings Miró had already developed succinct formal language, reduced to a few abstract shapes in brown, black and white, Miró's 1928 *Collage* combines simplicity of form with poverty of materials to almost shocking effect. Thick bars of oil paper and old wallpaper lie like a grid over the pale oval background framed with roofing felt. Were this compact composition not overlaid with the delicate and graceful drawing of a female dancer, the work would be dark and heavy, rather than the playful piece that it is. The drawing is like a fragile fabric draped over the grid. The nailed-down background remains empty. The crudity of the material is emphasised by the

fragility and elegance of the drawing, which is the focal point of the image. The dancer's body is covered by areas of shadow and the materiality of the collage elements appears to dissolve into thin air. This paradoxical effect make the words of Louis Aragon, poet and friend of Miró, on his Surrealist colleague's work all the more telling: "No matter what it is, however transient it may be, this painter uses everything to express himself, and the more worthless and repulsive it is to those around him, the better."

Meanwhile, other collages are less concerned with the ordinariness and banality of the materials used than with the poetic effect of the clash between different levels of reality. In a *Papier collé* of 1929 Miró cuts two circles out of roofing felt mounted on coarse paper, filling them out in turn with other paper in beige and gray-brown, along with wires and scraps of cloth, and introduces one of his typical drawings. The circles form a universe which, full of motion, also involves the "heavy" elements, integrating them into the circulatory movement.

In a similar work, also dating from von 1929, Miró dynamizes the pictorial space with a variety of drawn shapes. In the centre a pointed hat rotates on a stick. Below, an arrow shoots from left to right. Two spherical shapes hover like planets on the left, with a small feather floating at the top right of the collage. The horizontal line drawn across the paper by the artist and hence right across the whole configuration is also light, almost weightless. With the fibrous tips attached to it, it appears to sway back and forth in the wind, so picking up on the idea of movement.

Papier collé, 1929

JOAN MIRÓ

Woman

1934, pastel, 109 x 73 cm
Private collection

**"Form for me is never something abstract,
it is always a token of something. ... For me,
form is never an end in itself."**

Joan Miró

From 1934, when Joan Miró's work entered its so-called "savage" period, there was both cruelty and desperation in his depictions of the human figure. This was a reflection of the historical situation, with the rise of Fascism in Europe and the growing threat of a Second World War. At the same time, there was obvious misogyny in Miró's representations of women as distorted, caricatured figures, every bit as striking as the female creatures that cropped up in Picasso's works of the same period.

Miró, who at this stage frequently used soft, coloured paper and pastels, not only put his subjects through the same horrific metamorphoses as Picasso; he went further still, stressing their ungainliness by using strident colours, whose glowing intensity was underlined by his pastel technique. To the spectator, the woman's body appears soft and bloated, except for the firm horizontal axis, on the left and right of which are tied claw-like hands.

In terms of materiality and structure, she is similar to the bone-like forms from which Picasso shaped his *Bathers* in the early 1930s.

As with Picasso's figures, the head is small in relation to the body, and Miró's use of bright colours gives her a birdlike appearance. However, she could also be a huge insect with feelers, like a female praying mantis, which devours the male after sex and which so fascinated the Surrealists. Miró's *Woman (Femme)* is also depicted as a dangerous seductress. Despite the ugliness of her massive body she sends out signals to men who seem to be completely in her thrall. Her breasts, her sex, her rounded hips and large, horizontal orifices blur their vision, leaving them vulnerable to her dangerous allure.

While Miró's 1934 woman is frightening and obsessive, the one portrayed in his 1937 pencil drawing *Naked woman climbing a staircase (Femme nue montant un escalier)* is pure caricature. Perched on top of a more or less normally proportioned but thoroughly unappealing body is a bald head with a huge nose, which is also dragged downwards by the weight dangling from it. The naked woman is climbing a staircase and this artificial pose is vaguely reminiscent of an academic nude study. Miró's woman, however, has been robbed of any beauty or idealisation. All that remains is her sexuality.

Picasso's extremely negative perception of women in the early 1930s can be explained by his tense relationship with his first wife Olga. In Miró's case there is no such real-life justification. "The word 'love' as opposed to 'understanding' is an abstract idea," he told Georges Raillard in 1977 during a conversation about the relationship between the sexes. "Lovers are creatures who fight, who consume one another. But I instinctively mistrust abstract ideas."

Naked woman climbing a staircase, 1937

78

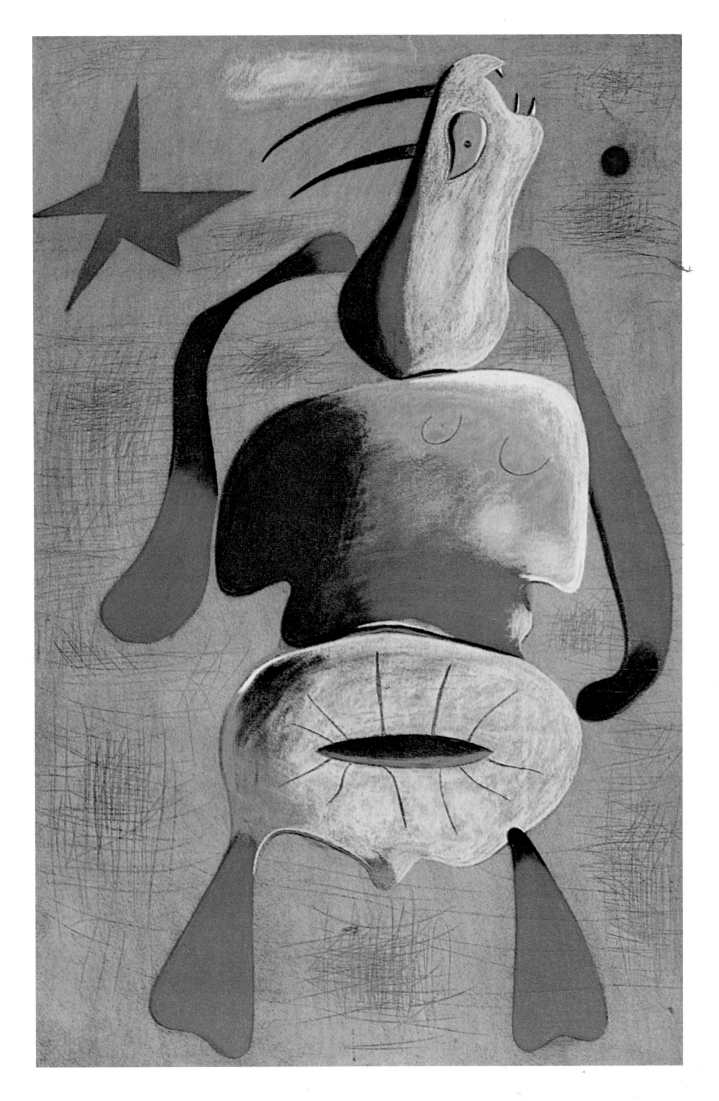

MERET OPPENHEIM

Fur Breakfast

1936, fur-covered cup, saucer and spoon, height 7 cm
New York, The Museum of Modern Art,
Purchase. 130.1946.a–c

"Freedom is not given. It must be taken."
Meret Oppenheim

b. 1913 in Berlin, d. 1985 in Basle

Meret Oppenheim was 18 years old when she went to Paris to become an artist in May 1932. Through her friendship with Hans Arp and Alberto Giacometti she quickly made contact with André Breton and the Surrealists. They invited her to take part in a group exhibition and – largely because of a brief love affair with Max Ernst in 1934 – she was accepted into a circle of writers, thinkers and artists with Surrealist sympathies.

She appears to have been a member of that circle until 1935, but after she completed the work that came to symbolise her association with the Surrealists, her ties with them seem to have loosened. *Fur Breakfast (Déjeuner en fourrure),* shown at the 1936 exhibition of Surrealist objects along with other works by Oppenheim, met with a very positive response from the Surrealists. It was André Breton who came up with a title for the fur-covered cup, saucer and spoon. It was an ironic reference to Manet's famous painting *Le déjeuner sur l'herbe*. Oppenheim, meanwhile, simply called her object *Cup, saucer and spoon covered with fur.* The Surrealists' high regard for *Fur Breakfast* seems to have been due mainly to the fact that, in creating this object, Oppenheim succeeded in transforming Surrealist theories into art. In his essay "The Crisis of the Object", published shortly after the exhibition at Galerie Ratton, André Breton demanded that, as a sign of rebellion, everyday things should be given different functions and utilitarian objects should undergo a process of mystification, the objective being to "traquer la bête folle de l'usage" – "hunt down the mad beast of habit". *Fur Breakfast*

translates the concept of alienating objects and distancing them from reality in a style that goes way beyond the absurdity and the element of surprise that the Surrealists sought.

Oppenheim's comments about the origins of *Fur Breakfast* were as down-to-earth as her choice of title for the piece. She seemed to be trying to trivialise her work and in so doing tone down its effect, which, while enigmatic, appealed to a popular audience. According to the artist, it all began with a conversation with Picasso, whom she met by chance in a café. They talked about the special role of the café, to which *Fur Breakfast* is a very direct reference, as a meeting place. To the Surrealists, the café not only meant conviviality and the continuation of the bohemian tradition, it was also the ideal setting in which to conspire and collaborate.

At the famous "Fantastic Art, Dada, Surrealism" exhibition that took place in winter 1936/37 at the Museum of Modern Art in New York, the reaction to *Fur Breakfast* was perhaps even more positive than it had been at the recent Surrealist event in Paris. Alfred H. Barr, who organised the New York show in collaboration with the Surrealists and who, when the exhibition closed, bought the work for MoMA, wrote that few works of art had so captured the public imagination in the same way as Oppenheim's Surrealist object, the fur-covered cup, saucer and spoon. Like Lautréamont's famous metaphor of the encounter of a sewing-machine and an umbrella or Dalí's soft watches, the fur cup turned the most bizarre impossibility into tangible reality. The feeling of excitement aroused by this object in tens of thousands of Americans was expressed in angry outbursts, laughter, disgust and delight, Barr reported.

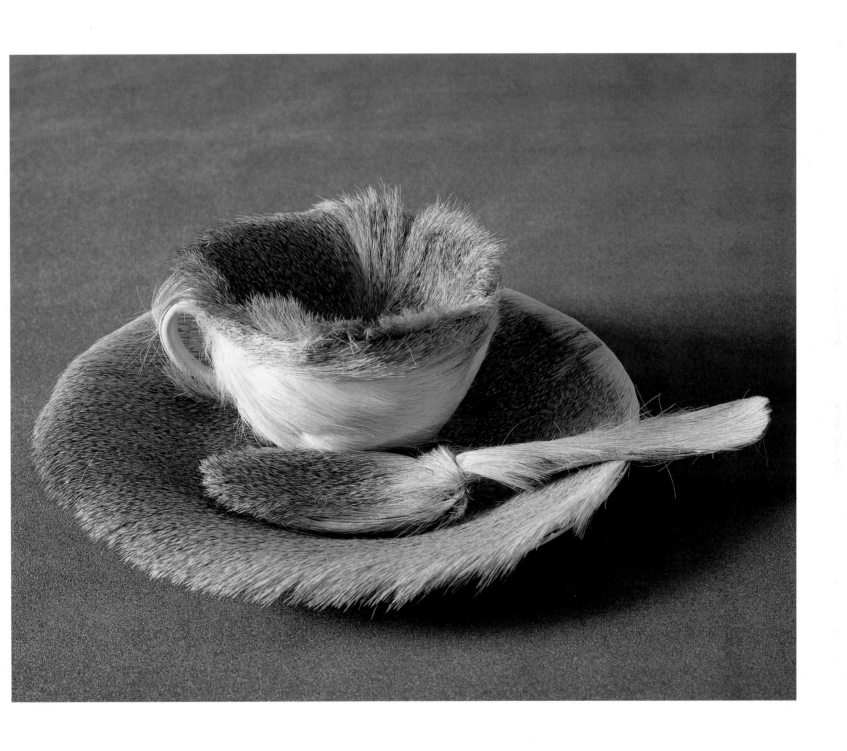

PABLO PICASSO

Composition with Glove

1930, sand on reverse of framed canvas, glove,
cardboard and plant material on canvas, 27.5 x 35.5 cm
Paris, Musée Picasso

"Art washes the soul of the dust of everyday."

Pablo Picasso

b. 1881 in Málaga,
d. 1973 in Mougins (near Cannes)

In its Surrealist phase, Pablo Picasso's work transcends every kind of boundary. The human body is turned into a stone skeleton, graceful bathers adopt acrobatically contorted poses and the face of the painter's young lover appears as a configuration of bits of iron. Not only does the physical nature of his subjects undergo unexpected transformation, the line between different media and genres always remains extremely fluid – painting imitates sculpture, sculptures consist of everyday objects, drawings and prints simulate every imaginable surface structure resulting from the use of hugely varying techniques.

The starting point for all these transformations and experiments was the traditional panel painting whose function was both imaginative and illustrative. The stylistic and formal unity of the work of art was broken down, conventional ways of seeing were blocked off so that the spectator was forced into a new, more direct engagement with the work of art.

Few works present such a head-on challenge to traditional assumptions as the sand-coated reliefs that Picasso executed in 1930, among them *Composition with Glove (Composition au gant)*. Here, the artist turned the canvas over and arranged the various elements of his relief in the hollow space created by the frame. But once again, the limits are overstepped. A bulging glove resembling a hand and shreds of cloth that look like seaweed spill over the edge and create a bizarre face in the middle.

Cut out of sturdy cardboard, the mask is similar to the faces in Picasso's paintings of the period – the openings for mouth, eyes and nose are neither symmetrical nor in their usual places, but are scattered in a seemingly arbitrary way. The configuration conveys the vague idea of a face and body, of a human presence. However, it is covered by a layer of grey sand, which distances it from the spectator. Under its ash-like coating, the relief could be an archaeological find, a long-buried relic of a bygone age, a fragment that has re-emerged from the ashes of Pompeii.

The 1932 *Composition with Butterfly (Composition au papillon)* exudes an air of decay. A dried leaf whose filigree structure is visibly disintegrating and a butterfly whose lifeless state intensifies our sense of its fragility, are flanked by two matchstick men, one made from string, the other from cloth, a drawing pin and matches. Here, too, the whole configuration – including the leaf and the butterfly – is covered with a unifying and simultaneously alienating layer of milky colour. Like the tide, it seems to have swept the things along with it, snatching them away from the flow of time and bringing them together.

Composition with Butterfly, 1932

Woman in a Red Armchair

1932, oil on canvas, 130.2 x 97 cm
Paris, Musée Picasso

"I paint things as I think them, not as I see them."

Pablo Picasso

Only with difficulty do we recognise the *Woman in a Red Armchair (Femme au fauteuil rouge)* as a human being. And we only come to this conclusion because we associate the idea of an armchair occupied by an amorphous mass with that of a portrait. However, if we compare the work with Pablo Picasso's other sketches, drawings, sculptures and paintings produced in the same period, we can see it as part of a stylistic development process during which he explored the connections between painting and sculpture. It was also the last in a series of portraits of Marie-Thérèse Walter, completed within a matter of days.

On 14 January 1932 he began by painting a picture of his lover, which showed the young woman elegantly leaning back in an armchair. Picasso constructed the portrait using soft lines extending ornamentally over the canvas. Then, on 26 January, it became the starting point for a work of a completely different nature, for which *Woman in a Red Armchair* can be seen as a preliminary sketch. The painter transformed the separate parts of the woman's body – head, arms, neck, breasts and belly – into abstract sculptural elements which he fitted together to form a bizarre skeleton, mirroring the basic structure of the earlier portrait.

In the early 1920s, Picasso went through a distinctly classical phase, experimenting with orthodox styles of painting and traditional subjects. In 1926 he adopted a completely new approach. His beautiful, carefully balanced figures underwent a metamorphosis, evolving step by step into monstrous, distorted, fragmented bodies, like those in the series of *Bathers* painted in the summer of 1927. For these, Picasso chose two different modes of representation. Either the bodies looked like cut-outs flattened onto the surface of the canvas so that the individual parts appear to be lined up side by side rather than belonging to an organic whole. Alternatively, the artist produced distinctly sculptural forms which fitted together to create a thoroughly ill-proportioned and often very ugly whole.

In Picasso's paintings and sculptures, this approach is combined with dramatic emphasis on materiality, either conveying an impression of soft fleshiness or simulating hard substances like stone or bone. In his experiments with the representation of the human body, Picasso not only thought analytically about its internal structure; he also tried to express the feelings, desires and projections associated with the female body, especially its sexual magnetism. It was this aspect of his work that specifically aligned him with the Surrealists at that period.

Sleeping Woman, 1932

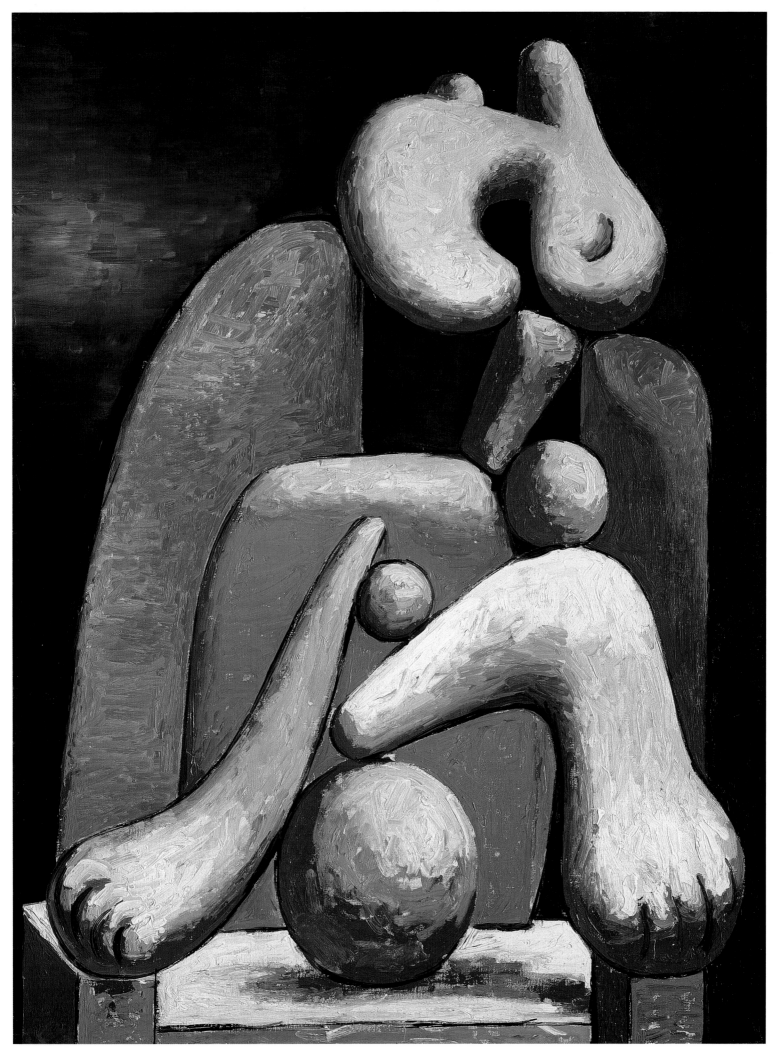

PABLO PICASSO

Corrida

1934, oil on canvas, 50 x 61 cm
Private collection

In 1934 Picasso took the *corrida* as the subject of a series of works ranging from quasi-naturalistic representations to extremely stylised versions of the bullfight. However, none of these works directly depict what happens in the bullring. They are more like allegories, a mythical vision that also found expression in Picasso's poetry of the period. The artist saw the bullfight as a ritual sacrifice and placed it on the same level as the cult of Mithras or the Crusades. The artist's visual images are echoed in his Surrealist poetry, in such lines as "when the bull with its horn opens the door of the horse's belly" (November 15, 1935), or "the horse spills its entrails like flowers that bend the arena, like sand crashing from clocks" (April 18, 1935). Picasso wrote of "pain written in large letters all around the arena" (November 7, 1935), and "the fine, delicate banquet of death" (January 20, 1936). The bullfight reveals a mystery that can be read in the entrails of the horse. It is Holy Communion: "the scent, the stench and the horror of the entrails exploding between the murderer's hands, blood gushes over the horse's belly and the Mass begins ..., the love feast of a whole race which plunges its hand into the entrails and searches for the heart from which the bull's life drains away" (November 7, 1935).

The 1934 painting *Corrida* is also full of contrasting concepts and emotions – unbridled brutality and carefully thought-out stylisation, the cruelty of nature and its sublimation in the beauty of art. Strong colours, black and white, yellow, red and green, spill into each other in the fight between horse and bull. The drama reaches its culmination in the great wound in the body of the horse, gaping and bleeding in the centre of the picture. The bodies of the two animals are interwoven, the heavy shape of the bull obviously representing evil, while the white body of the horse symbolises innocence. This allocation of roles not only runs though all Picasso's works whose protagonists are the bull and the horse.

In *Bull and Horse (Taureau et cheval),* a drawing dating from the following year, it appears even more precise. The bull, whose head shows anthropomorphic features, disembowels the horse and stands with its two forelegs planted in the open wound. While Picasso draws rage and brutality on the bull's face with exquisite precision, he merely sketches the contours of the dead horse, so downgrading it to no more than an anonymous victim.

In this configuration, horse and bull are not only victim and perpetrator; they also stand for woman and man and, ultimately, for innocence and evil, two opposing concepts on which Picasso was to construct his masterpiece *Guernica.* In that monumental painting, the artist's response to the brutal bombardment of the little Spanish town of Guernica, one of the last centres of Republican resistance, the horse and the bull are central figures, the bull portrayed as the ferocious embodiment of evil.

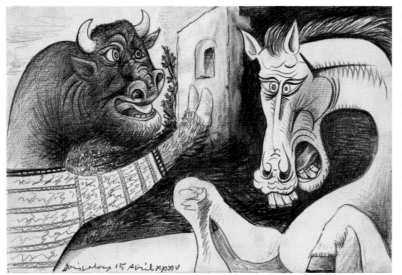

Bull and Horse, 1935

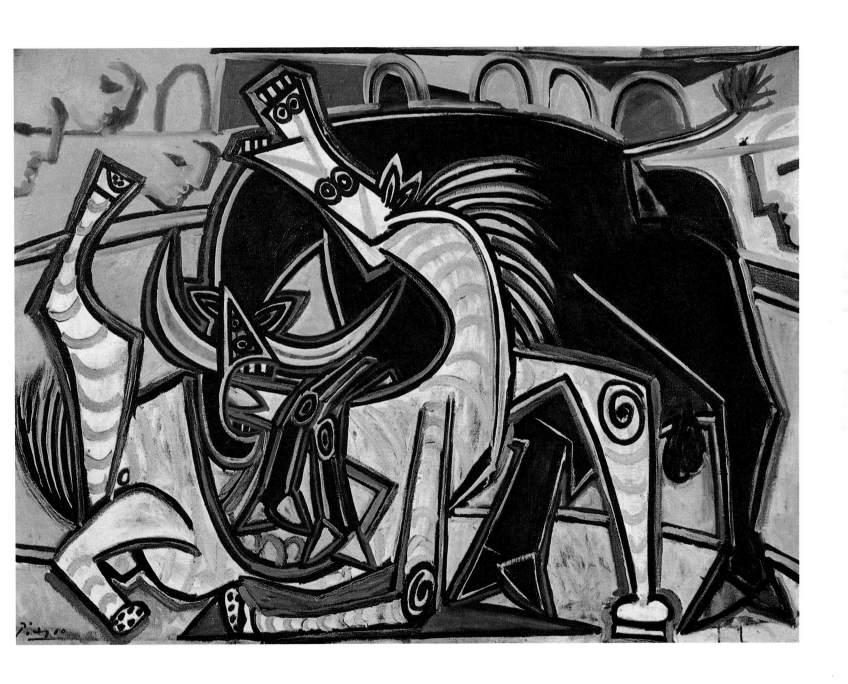

PABLO PICASSO

Woman with Foliage

1934, plaster, 39.5 x 21.5 x 26.5 cm
Private collection

During his Surrealist period, Pablo Picasso took a particularly intense interest in literature and sculpture. In 1930, Picasso bought the Château Boisgeloup, near Gisors in the French *département* of Eure, which offered huge spaces where he could work on his sculptures. Contemporary photographs of the château give some clue of the magical, surreal atmosphere of the place, in which various materials – scrap iron, kitchen utensils and everyday objects – were collected and then combined with finished sculptures to create total works of art from the most diverse bits and pieces.

The Surrealist, collage-like nature of Picasso's sculptures and the wide variety of materials used by the artist are reflected in the small statue *Woman with Foliage (Femme au feuillage).* The spectator is immediately struck by two very different elements: the leafy branch that the woman holds in her right hand and the small, rectangular box which Picasso uses as her face. It is precisely this everyday object worn like a mask that gives her such a deeply dramatic appearance.

She seems to be the mouthpiece for some alien power, a prophetess like Cassandra who, despite her awareness of future disaster, cannot turn away. Such classical associations are underpinned by the figure's sweeping, rhetorical gestures and her long, pleated garment, the pleated effect achieved by pressing corrugated cardboard against the plaster. The extremely naturalistic surfaces of the leaves are the result of a similar transfer process. Like palm branches or laurel leaves, they seem to have some symbolic significance. Nevertheless, their exact meaning remains unfathomable, for we do not know which myth or tragedy the *Woman with Foliage* refers to. Thus her words are incomprehensible, her gestures empty. This complete lack of meaning reduces her from an imposing presence to a figure of fun.

Four years previously, in 1930, with *Woman's Head (Tête de femme),* Picasso created a portrait of a woman that was ludicrous in quite a different way. This is also a collage combining all kinds of objects whose original function and meaning remain obvious but which, when put together, create a quite new and unexpected effect. The various pieces of iron, including a very recognisable colander, are welded together to form an aggressive and monstrous face, so absurd that it leaves the spectator with a stale aftertaste.

The act of breaking the human face into pieces and adding what are manifestly spare parts from the material world marks a new departure, opening up immense possibilities for the exploration of the realms of the irrational and the world of dreams.

Woman's Head, 1929/30

"Art is a lie that allows us to see the truth."

Pablo Picasso

Le violon d'Ingres

1924, gelatin silver print, retouched with
pencil and Indian ink, 31 x 24.7 cm
Paris, Musée National d'Art Moderne, Centre Pompidou

"I photograph the things that I do not wish to paint, the things which already have an existence."
Man Ray

b. 1890 in Philadelphia,
d. 1976 in Paris

Man Ray was one of the founders of Dadaism in the United States. He got to know the Surrealists in Paris when he moved to the city in the summer of 1921. Initially he devoted himself to photography, taking portraits of friends and colleagues, in which he created a magical atmosphere through special lighting effects. With the help of Jean Cocteau, Man Ray became portrait photographer to Paris' leading intellectuals and artists, his subjects including Gertrude Stein, Constantin Brancusi and Marcel Proust. After moving to rue Campagne-Première, where the photographer Eugène Atget also lived, Man Ray discovered a kind of ready-made form of photography, a process that created images without the intervention of the artist or even a camera. His "Rayographs" – outlines of objects on light-sensitive photographic paper – were exhibited for the first time in spring 1922.

To create a Rayograph, an object only had to be exposed to the light. This meant that a Rayograph was a work of pure chance that simply created itself. It was an image of transformation and alienation, a concept that fitted to perfection into the intellectual world of the Surrealists. One of the first published works to contain this new photographic process was a portfolio of twelve images by Man Ray, accompanied by Tristan Tzara's essay "Les champs délicieux" (Delicious Fields), which appeared in 1922.

On the other hand, the feeling of alienation produced by other photographs by Man Ray was based on the interplay between image and title. *The Enigma of Isidore Ducasse* is the title of a photograph of an object wrapped in a blanket and tied up with rope, while *Le violon d'Ingres (Ingres' Violin)* alludes to the two f-holes that Man Ray has drawn on the back of a female nude. He reinterprets the rounded shape of the young woman, transforming it into the soundbox of a musical instrument, so unleashing a whole chain of associations, largely inspired by the title of the picture.

We instinctively think of the importance of stringed instruments to the Cubists, who incorporated mandolins, violins and guitars into their complex still lifes. While in Analytic Cubism they were merely lifeless, sexless objects, Man Ray's "violin" gives the photo an erotic aura. This is underlined by the reference to the classicist painter Jean Auguste Dominique Ingres and his famous *Turkish Bath*, in which the central figure is a nude with her back to the spectator. It is precisely because Ingres has drawn her with such cold precision that she radiates such sensuality. The turban worn by Man Ray's model picks up on Ingres' oriental ambience, but is also an ironic comment on the chilly eroticism of the Turkish bath scene. The title *Le Violon d'Ingres* also alludes to the long tradition of music-making as an allegory for loveplay. From Man Ray's perspective the instrument is simply ready and waiting for the soloist.

Champs délicieux, 1922

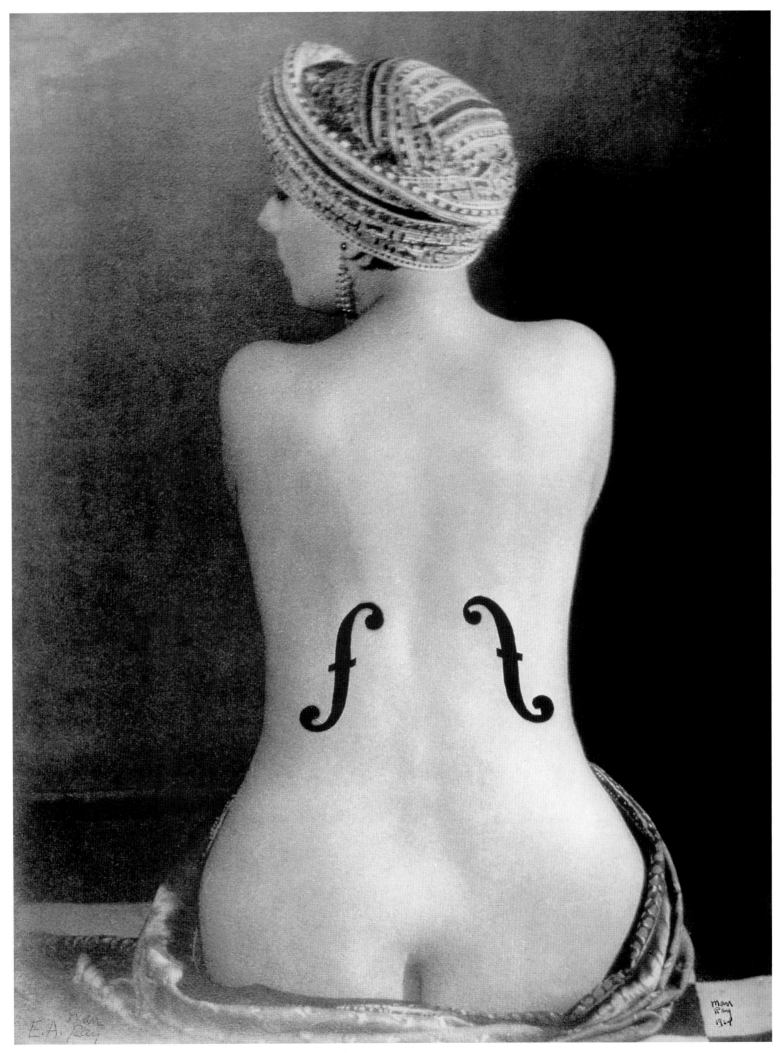

YVES TANGUY

The Dark Garden

1928, oil on canvas, 91.4 x 71.1 cm
Düsseldorf, Kunstsammlung Nordrhein-Westfalen

**b. 1900 in Paris,
d. 1955 in Woolbury (USA)**

Yves Tanguy felt his vocation as a painter at the age of 22. From the open platform of a Paris bus he saw two paintings by Giorgio de Chirico displayed in the window of the Galerie Paul Guillaume on the rue de la Boétie. One of them was *The Child's Brain.* Shortly after that experience, without having undergone any formal training, he began to paint in watercolours and oils. Tanguy was a purely self-taught painter who developed his own style and techniques in association with other artists. In the early days, the work of Giorgio de Chirico and Max Ernst were particularly significant.

His relationship with the Surrealist group and particularly with André Breton also proved crucial and until his departure for the USA in 1939 he remained Breton's loyal supporter. He was a close friend of Jacques Prévert and Marcel Duhamel, with whom he shared a house on the rue du Château, where in the early 1920s many of the Surrealists would meet regularly to enjoy long drawn-out games of *Cadavre exquis.*

Tanguy's early paintings adopt motifs from Chirico and Ernst, but these are surrounded by an atmosphere more akin to Miró's abstract, light-filled backgrounds. The same, indefinable, supernatural light dominated Tanguy's paintings from the outset, imbuing them with a mysterious chill. In the course of the 1920s, Tanguy completely abandoned figurative elements in his painting and set off in a completely opposite direction. As a setting he used a bizarre, other-worldly landscape which he populated with organic forms.

The damply shining surfaces of these figures and the impression they give of softness and malleability are reminiscent of Dalí, whose paintings of boneless limbs probably inspired Tanguy. *The Dark Garden (Le jardin sombre)* is also occupied by these faceless beings which nevertheless appear too mobile to be identified with the standing stones found on the coast of Tanguy's native Brittany. As they move in from the left of the painting, these mostly phallus-like creatures are like a mob overrunning and disturbing the orderly structure of the composition, which consists of mechanically drawn wavy lines, creating a deep, dark surface to the sea that merges with the striped pattern of the turquoise sky.

Although these structures rendered on canvas using different techniques reflect the real relationship between sea and sky, it is precisely the artificiality of their appearance that creates the picture's overwhelmingly strange and threatening atmosphere. Tanguy lets the spectator see into a universe far removed from the real world, where there is room for neither Miró's poetically twinkling eye nor Dalí's solid nightmare vision.

"But with Tanguy, it will be a new horizon, one in front of which the no longer physical landscape will spread out."

André Breton

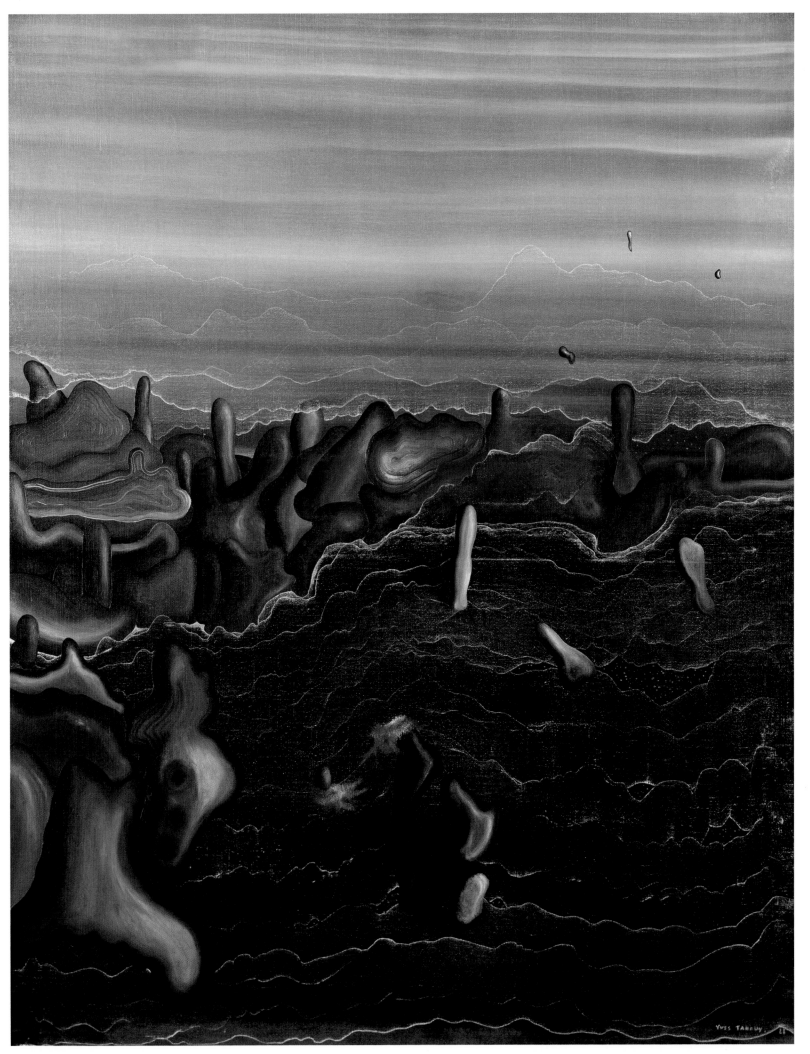

Day of Slowness

1937, oil on canvas, 92 x 73 cm
Paris, Musée National d'Art Moderne, Centre Pompidou

There is a tendency to compare Yves Tanguy's landscapes to photographs of an alien planet, since it is hard to find words to describe the magical chill and latent menace of his invented scenery. The world he depicts, in which composition and use of light are often surprisingly close to those in the paintings of Salvador Dalí, have one decisive difference. While Dalí captures his personal obsessions in very precise visions, Tanguy's art is detached and passionless.

His dream paintings, which only on closer examination are revealed as nightmare visions, produce a vague unease in the spectator. André Breton claimed that it would take the next generation to decipher Tanguy's work. For Breton, Tanguy's significance lay in his refusal to compromise. He made absolutely no concession to anything approaching reality and this is what gave his painting its surreal and mysterious character.

The novelty and uniqueness of Tanguy's painting lies in its elegance and the artist's ability to turn ugliness into eccentric beauty. This quality became increasingly evident in his work in the late 1930s, the period to which *Day of Slowness (Jour de lenteur)* belongs. With great precision, Tanguy isolates the individual figurative elements from their background. He reintroduces the bizarrely shaped objects apparently sprouting from water, or other soft substances, that featured so strongly in his earlier paintings.

In his later works the surreal figures also cast deep shadows, so creating space that is in fact non-existent. The lines in the background, floating as though caught by the soft-focus lens of a camera, are transformed into flat, abstract structures. The line marking the transition from darkness to light could be the horizon, giving the impression that this is a landscape.

Against this abstract background, Tanguy sets two main figures. One recalls a knight on horseback brandishing a weapon, while another warrior sits astride the creature approaching snail-like from the right and resembling a tower. In the background, a third small figure on a red pedestal glides by. The whole scene is as silent as it is weird. We do not know whether it is set deep in the past or in the far distant future.

Which brings us back to the integrity of Tanguy's art, so highly esteemed by André Breton, poet and chief spokesman of Surrealism. Certainly, Breton was not just thinking about the painter's honesty as an artist. In the 1930s Tanguy was one of his most loyal friends who stood by him throughout all the conflicts within the Surrealist movement. However, in 1939 they went their separate ways, as Tanguy left for the USA in order to marry the American artist Kay Sage and to reach safety before the outbreak of the Second World War.

"The painting takes shape before my eyes, reveals its surprises in the course of its development, and it is precisely this that gives me the feeling of total freedom …"
Yves Tanguy

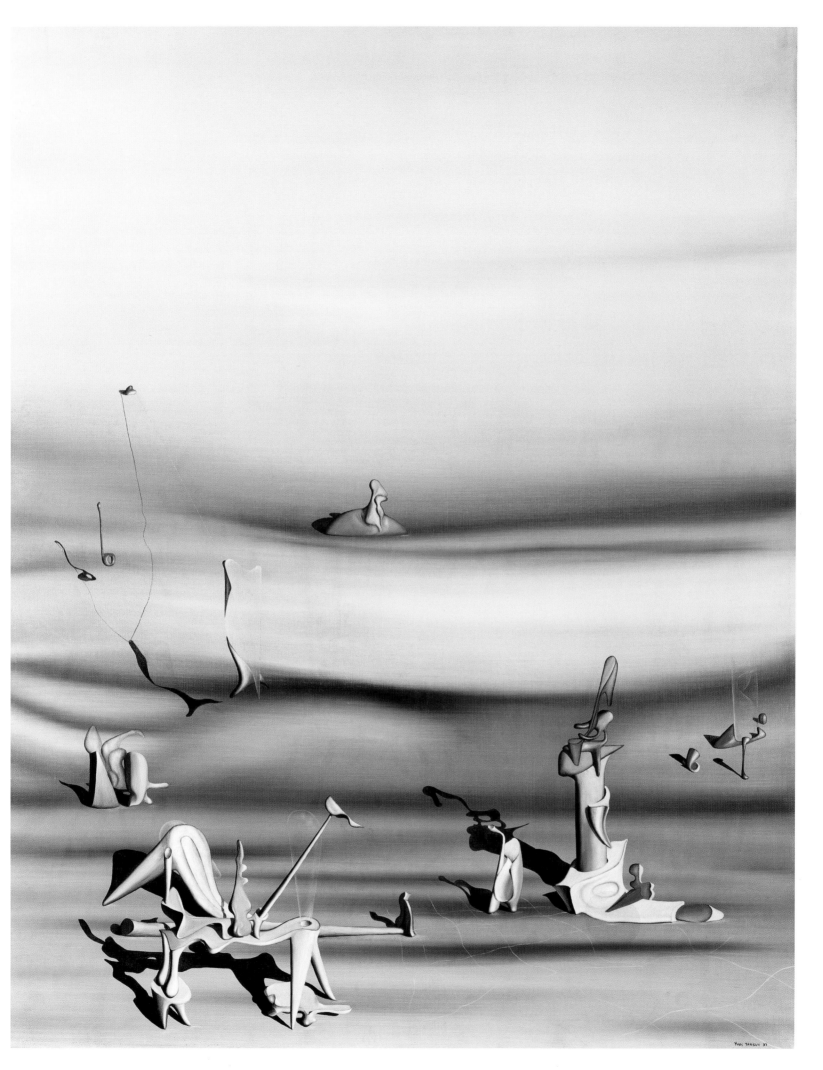

To stay informed about upcoming TASCHEN titles, please request our magazine at www.taschen.com/magazine or write to TASCHEN America, 6671 Sunset Boulevard, Suite 1508, USA-Los Angeles, CA 90028, contact-us@taschen.com, Fax: +1-323-463.4442. We will be happy to send you a free copy of our magazine which is filled with information about all of our books.

© 2009 TASCHEN GmbH
Hohenzollernring 53, D–50672 Köln
www.taschen.com

Original edition: © 2004 TASCHEN GmbH
Editorial coordination: Sabine Bleßmann, Cologne
Design: Sense/Net, Andy Disl and Birgit Eichwede, Cologne
Production: Ute Wachendorf, Cologne
English translation: Isabel Varea for Grapevine Publishing Services, London

Printed in China
ISBN 978–3–8365–1419–4

Photo credits:

The publishers would like to express their thanks to the archives, museums, private collections, galleries and photographers for their kind support in the production of this book and for making their pictures available. If not stated otherwise, the reproductions were made from material in the archive of the publishers. In addition to the institutions and collections named in the picture captions, special mention is made here of the following:
© Archiv für Kunst und Geschichte, Berlin: p. 19, 29, 34, 43, 49, 84
Artothek: p. 35, 50, 51, 52, 63, 68
Bildarchiv Preußischer Kulturbesitz, Berlin: p. 73
Bridgeman Giraudon: p. 25, 27, 33, 47, 54, 66, 87
Fondation Beyeler, Riehen/Basle: p. 55
Fundació Joan Miró, Barcelona: p. 78
Paul-Klee-Stiftung, Kunstmuseum Bern: p. 59
Galerie Jan Krugier, Ditesheim & Cie, Geneva: p. 53
Kunstsammlung Nordrhein-Westfalen, Düsseldorf © Photo Walter Klein: p. 75, 93
Moderna Museet, Stockholm © Photo Åsa Lundén: p. 12
Öffentliche Kunstsammlung Basel: p. 10 (left + right)
Paris, Musée Picasso © Photo RMN – Franck Raux: p. 20, Béatrice Hatala:

p. 82, 83, 86, 88, R.G. Ojeda: p. 85
Centre Georges Pompidou – MNAM-CCI, Paris © Photo CNAC/MNAM Dist. RMN: p. 30 (above, photo: Michèle Bellot), 30 (below, photo: Jacques Faujour), 56, 57, 70, 71, 72, 90, 95, front cover
Centre Georges Pompidou – MNAM-CCI, Paris © Photothèque: p. 8, 11, 13, 17 (left)
© Photo SCALA, Florence/The Museum of Modern Art, New York 2004: p. 39, 61, 81, back cover

Reference illustrations:
p. 30 (above): Gilberte Brassaï, *Brassaï with camera*, 1955, Private collection
p. 30 (below): Brassaï, *Rolled-up bus ticket (Billet d'autobus roulé),* 1932, gelatin silver print, 17 x 23.5 cm, Paris, Musée National d'Art Moderne, Centre Pompidou
p. 34: Giorgio de Chirico, *The Two Sisters (Le due sorelle),* 1915, oil on canvas, 55 x 46 cm, Düsseldorf, Kunstsammlung Nordrhein-Westfalen
p. 40: Salvador Dalí, *Study for "Weiche Konstruktion …",* pen, ink and pencil on paper, 23 x 18 cm, Private collection
p. 42: Salvador Dalí, *Venus de Milo with Drawers,* 1936/1964, painted bronze and fur, height 96 cm, Private collection
p. 50: Max Ernst, *At the First Clear Word (Au premier mot limpide),* 1923, oil on plaster, transferred to canvas, 232 x 167 cm, Düsseldorf, Kunstsammlung Nordrhein-Westfalen
p. 52: Max Ernst, *Loplop,* 1932, oil on canvas, 100 x 81 cm, Private collection
p. 54: Max Ernst, *Capricorn,* 1948/1964, bronze, 245 x 207 x 157 cm, Paris, Musée National d'Art Moderne, Centre Pompidou
p. 56: Alberto Giacometti, *Woman with her Throat Cut (Femme égorgée),* 1932–1940, patinated bronze, 21.5 x 82.5 x 55 cm, Paris, Musée National d'Art Moderne, Centre Pompidou
p. 66: René Magritte, *The Voice of Silence (La voix du silence),* 1928, oil on canvas, 54 x 73 cm, Private collection
p. 68: René Magritte, *The Empire of Lights (L'empire des lumières),* 1953, oil on canvas, 146 x 114 cm, Private collection
p. 70: André Masson, *Automatic Drawing (Dessin automatique),* 1925/26, Indian ink on paper, 30.5 x 24.1 cm, Paris, Musée National d'Art Moderne, Centre Pompidou
p. 72: Matta, *Offences (Les délits),* c. 1942, crayon and ballpoint pen on paper, 57.3 x 72.7 cm, Paris, Musée National d'Art Moderne, Centre Pompidou
p. 74: Joan Miró, *Photo – This is the Colour of my Dreams (Photo – Ceci est la couleur de mes rêves),* 1925, oil on canvas, 96.5 x 129.5 cm, New York, Private collection
p. 76: Joan Miró, *Papier collé,* 1929, sheets of paper, wire, rags and roofing felt on plywood, 107 x 107 cm, Private collection
p. 78: Joan Miró, *Naked Woman Climbing a Staircase (Femme nue montant un escalier),* 1937, pencil on cardboard, 77.9 x 55.8 cm, Barcelona, Fundació Joan Miró
p. 82: Pablo Picasso, *Composition with Butterfly (Composition au papillon),* 1932, textile, wood, plant material, string, drawing pins, butterfly, oil on canvas, 16 x 22 cm, Paris, Musée Picasso
p. 84: Pablo Picasso, *Sleeping Woman (Femme endormie),* 1932, Location unknown
p. 86: Pablo Picasso, *Bull and Horse (Taureau et cheval),* 1935, pencil on paper, 17.5 x 25.5 cm, Paris, Musée Picasso
p. 88: Pablo Picasso, *Woman's Head (Tête de femme),* 1929/30, painted iron and lead, colanders, springs, 100 x 37 x 59 cm, Paris, Musée Picasso
p. 90: Man Ray, *Champs délicieux,* 1922, Rayographie, 22.1 x 17.3 cm, Paris, Musée National d'Art Moderne, Centre Pompidou

Seite 1
RENÉ MAGRITTE
The Treachery of Pictures
1928/29, oil on canvas, 62.2 x 81 cm
Los Angeles, Los Angeles County Museum of Art

Seite 2
MAX ERNST
The Tottering Woman
1923, oil on canvas, 130.5 x 97.5 cm
Düsseldorf, Kunstsammlung Nordrhein-Westfalen

Seite 4
RENÉ MAGRITTE
Attempting the Impossible
1928, oil on canvas, 105.6 x 81 cm
Private collection